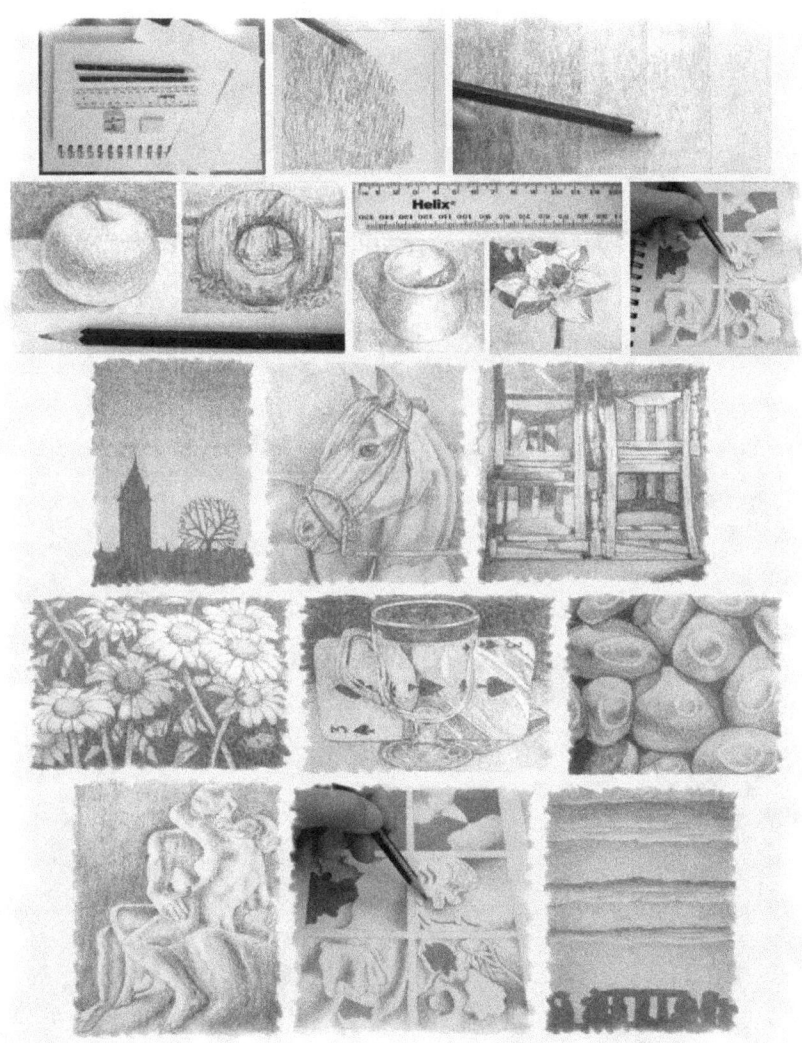

BEGIN DRAWING WITH 8 EXERCISES AND 8 PROJECTS

ACHIEVABLE GOALS TO GET YOU TO DRAW

RACHEL SHIRLEY

First Published in 2019 by Rachel Shirley. Text, photographs and illustrations copyright Rachel Shirley 2019. All rights reserved. The Right of Rachel Shirley to be identified as the author of this work has been asserted in accordance with the Copyright Designs and Patents Act 1988 Section 77 and 78.

ISBN: 9781692588489

To Harriet and Joseph

CONTENTS

Introduction		5
Exercise 1	Even Shading within a Square	9
Exercise 2	Shading with Variables	12
Drawing Project 1	Shading a Dusk Skyline	14
Exercise 3	Tonal Shift within a Plane	18
Exercise 4	The Negative Space of Stonehenge	21
Drawing Project 2	Stonehenge at Sunset	22
Exercise 5	The Framing of Negative Space	26
Drawing Project 3	Beach Stones	28
Exercise 6	Drawing Symmetrical Shapes	32
Drawing Project 4	Distortions from Glass	38
Drawing Project 5	Stacked Chairs	43
Exercise 7	Jigsaw Pieces	48
Drawing Project 6	Horse Head	50
Exercise 8	Abstract Shapes	54
Drawing Project 7	Daisy Heads	56
Drawing Project 8	Auguste Rodin's the Kiss	60
	Glossary	64
	Other books by the author	65

INTRODUCTION

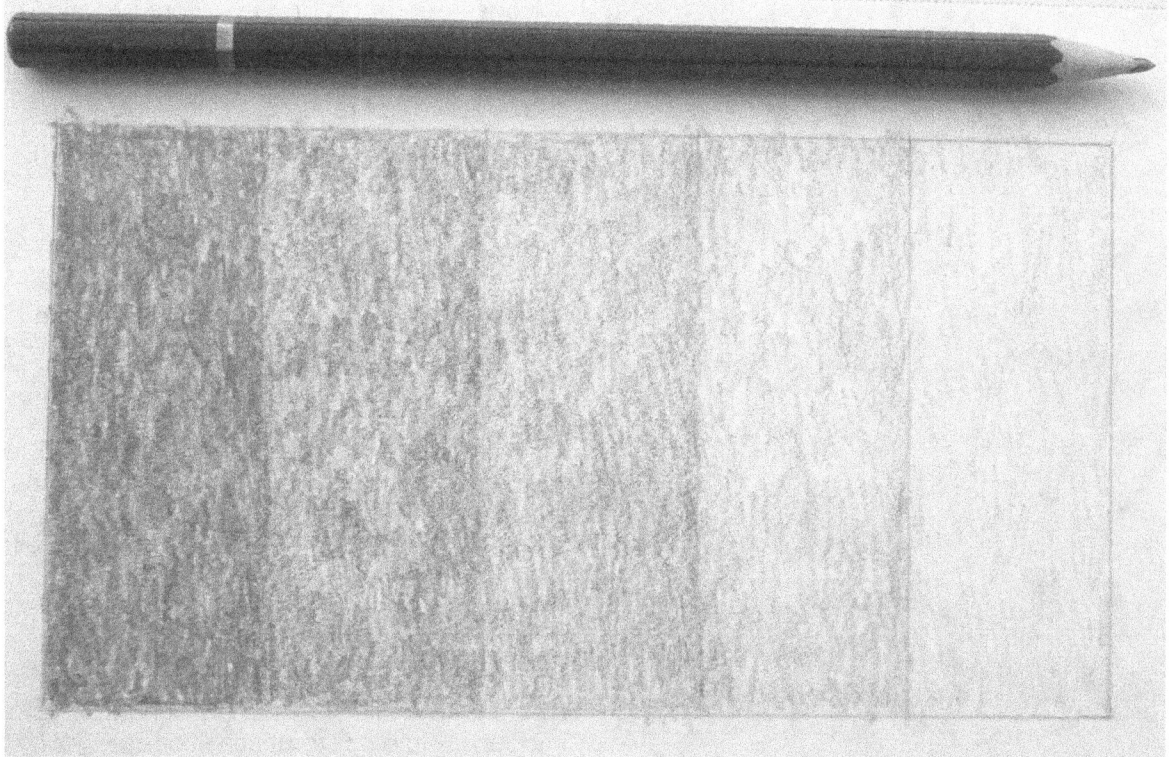

Getting yourself to Draw

The aim of this book is to get the beginner to draw.

And then to venture onto subject matter unforeseen.

Within this book, you will find 8 exercises and 8 drawing projects – two elements if you will.

The exercises will prepare you for the drawing projects. And the drawing projects are the subject matter themselves.

The book begins with simple mark-making. This is followed by drawing projects of basic silhouettes and skies. These are then followed by a variety of subject matter of increasing challenge, including beach stones, flower heads, a glass cup, a horse's head and figures.

Interim exercises serve to make these projects feel more 'doable'. Aspect of drawing such as incremental shading, drawing symmetry, jigsaw pieces, negative space and abstract shapes are explored.

This describes the structure of this book: interim exercises and drawing projects.

But the initial aim of this book is to urge the picking up of the pencil.

This can form the biggest stumbling block.

The reason might be due to one of the following: The beginner who has never owned a pack of drawing pencils; the art student making the difficult transition from cartoon doodler to realism; the career person who cringes at the idea of drawing, or the parent who has lost touch with the pencil due to family commitments.

Unleashing the Right Brain

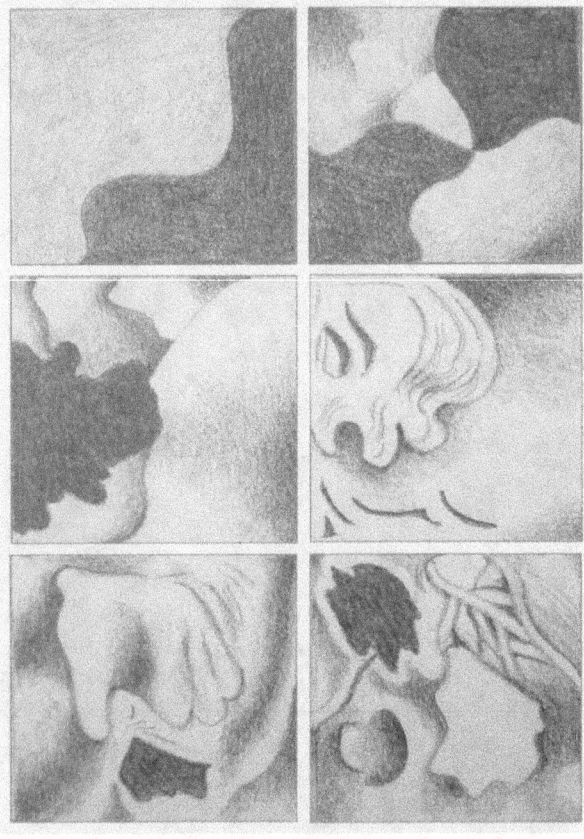

Drawing abstract shapes (explored in exercise 8) is good for developing visual awareness.

The problem might stem from a severe inner critic, not knowing how to make that first mark. It might be dissatisfaction with the drawing due to low visual awareness. The resultant renditions might be tight, smudgy or small, inhabiting one corner of the page.

A still life with pots might appear to slope to one side, or a street might possess an impossible vanishing point. Worst of all, you simply cannot find yourself drawing at all.

Resultant dissatisfaction may deter future attempts at drawing.

A tenet tends to exist that knowledge of proportions and vanishing points necessary before even beginning to draw. My experience has found this to be untrue.

Really, drawing is about appealing to the instinctive part of the brain that sees without assumptions. And then to practice.

Realistic goals form the key to success. Success feels good and therefore practice is more likely to occur afterwards. To this end, the exercises are designed to make each drawing project feel more achievable.

But it all begins with seeing. Without seeing, improvement isn't possible because the problem cannot be identified.

Objects without Labels

Visual awareness exists in the right side of the brain. The left side is full of 'shoulds', where assumptions are made about the subject matter.

For instance, all chairs 'should' have four legs, a seat and a backrest. From certain angles, these aspects vanish, as can be seen from drawing project 5. All daisies are 'pale'. In fact, they can appear dark, as seen from drawing project 7. These rules commandeer only when we forget to 'look' and notice what is seen in front.

To reflect the aim of this book, you will find essential instructions supported with step by step imagery, with a call to action – to see what is in front. And then to draw.

Here, you will find drawing projects and interim exercises designed to make the lifting of the pencil easier. As will be seen, minimal art materials are required to complete each task.

I wrote my first drawing guide, *Draw What You See Not What You Think You See* after encountering students within my class who really struggled to draw. And yet in the same class, other students exhibited a natural flair for drawing.

It seemed the ability to draw stemmed from intuition rather than from intellectual knowledge about the world.

I believe this intuition potentially exists within all of us, for drawing ability lives in the right side of the brain. We all possess (with the rare exception) a right cerebral hemisphere. We just need to tap into it. This book aims to pave the way.

The Five Principles of Drawing

The exercises in this book explore one or more of the five principles of drawing. These principles are:

1 Outlines: These are the edges of the objects drawn.

2 Spaces: These are the areas found inside and outside of the outlines.

3 Relationships: This is how one feature in the drawing relates to another regarding orientation, size and location.

4 Tonality: This is light and shadow, the shading.

5 The whole: This is how the drawing looks in its entirety.

But really, there is a sixth principle that concerns all of these: visual awareness. Without visual awareness, none of the above can be expressed accurately.

Projects and Exercises

The practice of these principles is vital to developing drawing ability. The tasks within this book have been formulated to this end.

The exercises serve to link the drawing projects together and provide the setup.

You can work through each section from beginning to end like an inchworm, or start at a random place and work your way round like a grasshopper. You can complete some or all of the tasks as needed. But activities will be found to suit most abilities.

Freehand Drawing

All the drawings within this book have been completed freehand, without the aid of tracing paper, compasses or protractors. Rulers are used only for drawing 'frames', which, as will be seen, makes the drawing manageable.

Imperfections will therefore be evident. This is different to drawing errors. Imperfections in the form of slight wobbles in lines and faint scribbles add character and charm to a drawing. It proves the drawing has been completed via hand rather than draughtsman tools. For this reason, I have allowed my imperfections to remain to demonstrate that imperfections form part of our creations – not a perfectly straight line or airbrushed tones.

With a lenient approach, you will find yourself developing your own drawing style as you improve.

I hope you will enjoy the journey through this book – and hopefully beyond.

But first, an outline of the drawing equipment you will need to get started.

Drawing with minimal art materials and fuss.

The Drawing Materials

By definition, drawing is about line and tone, which can be expressed by the simplest means. Only the following art materials have been used for this book.

HB and 2B pencils. Pencils in the H range are hard, and therefore could damage the paper. Pencils beyond the 2B range are very soft and will wear down quickly. A HB pencil is ideal for the preliminary drawings in this book; it is not too dark, but sufficiently soft to express lines without exerting excess pressure onto the paper. The 2B pencil is ideal for shading.

A pencil sharpener/scalpel. Sharpeners that contain the shavings are convenient and will keep the drawing area clear of debris. A good sharpener will retain a sharp point. A scalpel can be used if preferred.

An eraser. Yes, it is allowed. A good quality plastic eraser will not leave smudgy marks. Old erasers or those left in the sun tend to harden and damage the paper.

Good quality white drawing paper. Don't use thin paper or print paper. Look for an everyday sketchbook with pages of around 150 GSM. Hot pressed paper has a smooth surface, ideal for detail. Cold pressed paper has a goose-bump grain, ideal for textured shading. Avoid sketchbooks larger than A4 at this stage as the large blank pages can look intimidating if a beginner. An A5 sketchbook with a slight texture has been used here. I prefer a sketchbook with a ring-binder rather than glue-bound, as the latter does not hold the pages so securely. Mine has faint punch marks on the inner margin, for ease of detaching without the page tearing.

A 12in (30cm) ruler. This is needed for drawing frames. Frames are helpful for determining the edges of the composition and to make the drawing manageable. I never allow the dimensions of the drawing paper to determine the proportions of the drawing.

(Optional) bulldog clips. These could be useful if attaching the drawing paper onto a firm surface, such as a drawing board.

A hand-mirror will come in useful for viewing the drawing in reverse. This will highlight skewed or crooked elements rendered invisible if working too intensively.

It can be seen that lots of complex drawing equipment unnecessary to begin drawing. However, as you build in confidence, you may venture onto other mediums which might be pastels, crayons, ink or even paint.

So, let's begin!

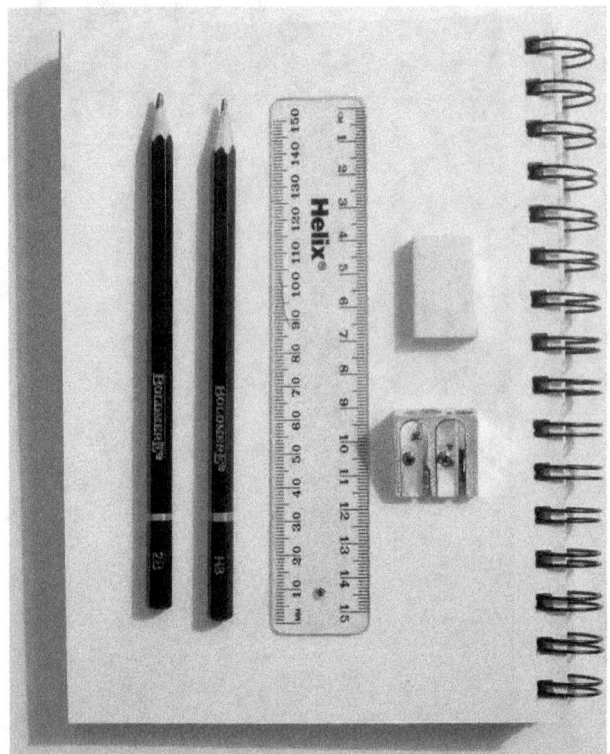

The art materials used in this book: A5 sketch book, ruler, HB and 2B pencils, eraser and sharpener.

Exercise 1: Even Shading within a Square

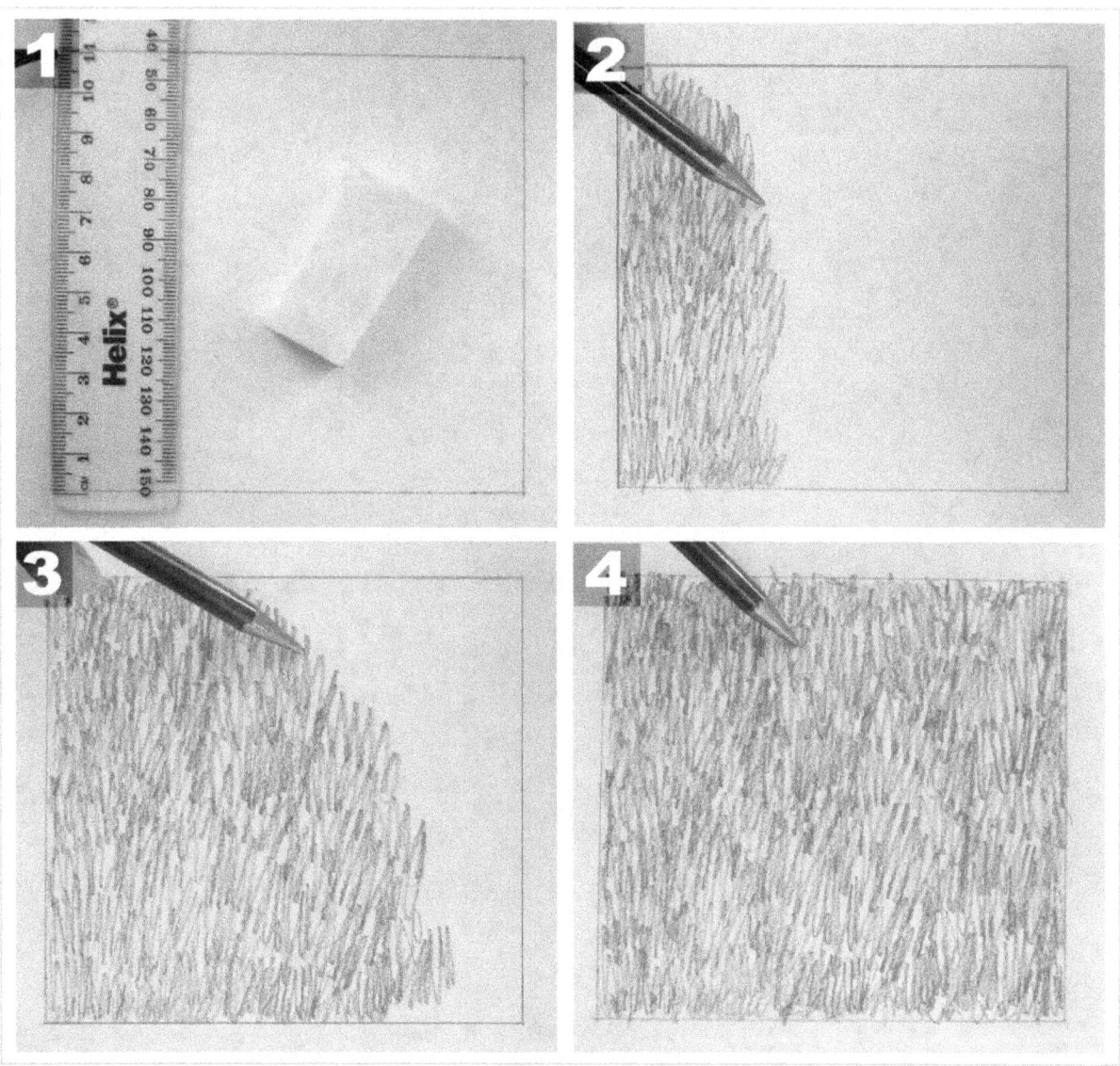

This first exercise simply concentrates on making marks, as explained earlier. The aim is to shade a confined area without variables. This means no patchiness, unevenness or marks that stand out.

1 First, draw a frame. Here, it is a square measuring 11cm. This square frame should lie roughly in the centre of the A5 sketching paper.

2 With a 2B pencil, lightly shade into various directions, allowing some of the marks to overlap.

3 I kept moving the pencil in similar fashion across the square, retaining even pressure.

4 Keep checking the overall appearance of the square to ensure the marks are even and uniform. Don't worry about straying out of the square, just ensure the marks are uniform and even in nature.

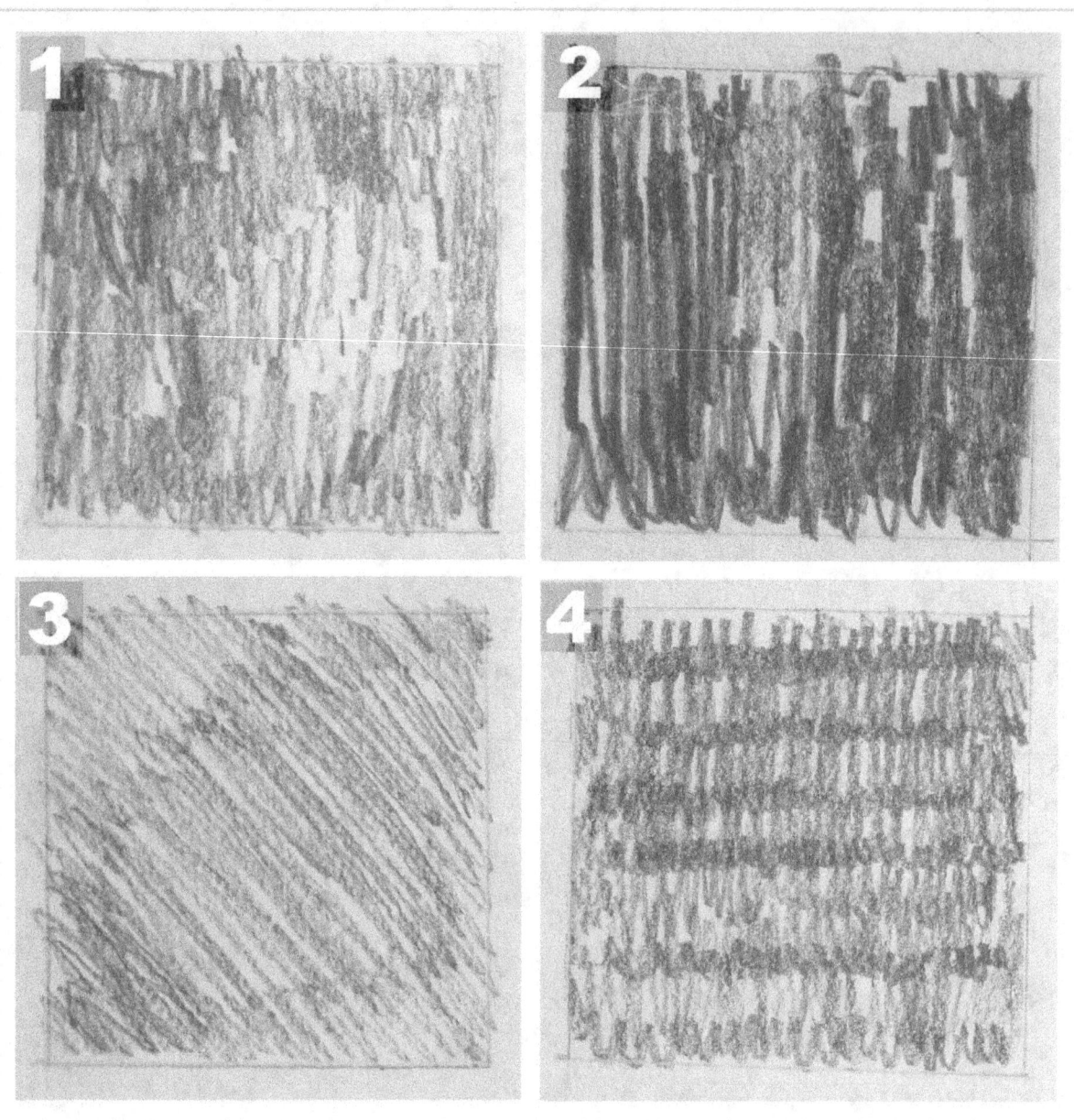

The images show what to avoid.

1 Guard against bald patches between pencil marks. Lightly fill these in with similar marks to retain a uniform feel.

2 Avoid working too dark initially, or little scope for shading on top will be given. Rubbing out dark marks will leave unwanted smudges.

3 Watch out for regimental or harsh lines working in the same direction. Rather than use the tip of the pencil, use the edge for soft suggestion. This will prevent a harsh finish.

4 Look out for overlapping marks that result in unwanted stripes in the shading. Work the pencil in various directions, tapering off in places.

Gaining distance from the shading will provide an overall view.

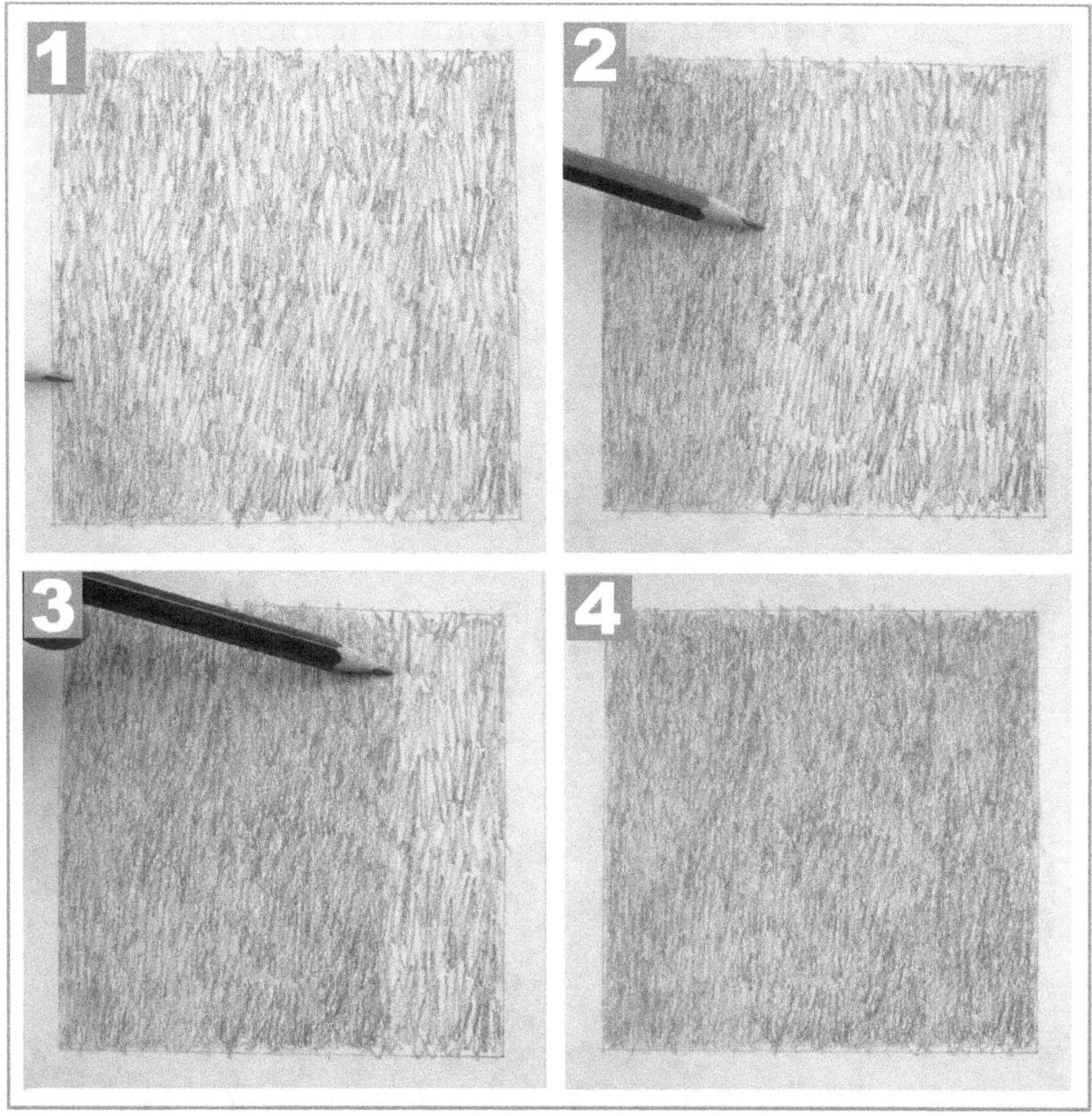

Now it is time to work on top of the initial layer. Working in layers is a good way of creating soft (but not too perfect) shading.

1: With the soft edge of the pencil, lightly work the shading in different directions in similar fashion to the first layer, but with added softness.

2: Keep working the pencil across the square, with light strokes, moving in different directions. Again, look out for marks that draw the eye.

3: Keep checking that no area is darker or paler than the rest of the square. Retain even pressure, working the pencil across the square.

4: Work over previous areas if necessary. The effect sought after is a smooth and even area of shading, but not like an airbrush.

Exercise 2: Shading with Variables

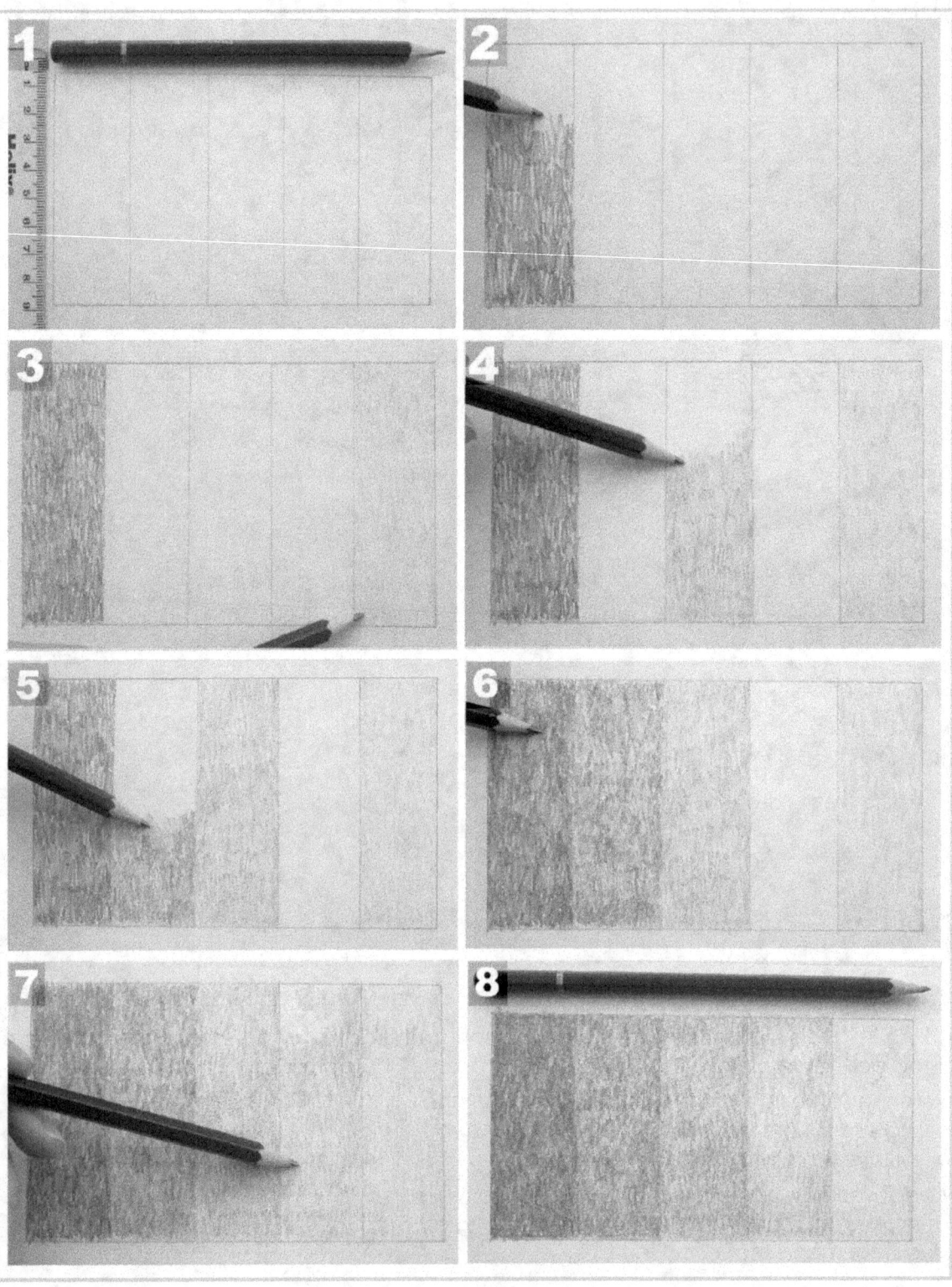

This second exercise builds upon the first regarding the rendering of tones.

The expression of incremental tones provides the set up for drawing project 1: Shading a Dusk Skyline.

Here, the pressure applied via the pencil varies. This offers scope for expressing a range of tonal values within each area. The aim is to keep the pencil moving and to get a feel for the how the pencil translates when various pressures are applied. Again, I used a 2B pencil.

1 I drew a rectangle measuring 15x8cm. I then divided the rectangle into five. Each segment will measure 8x3cm. This will provide a manageable area in which to explore shading.

2 With a 2B pencil, I shaded in the far left segment, using similar shading method to exercise 1. Move the pencil in various directions, avoiding marks that draw the eye such as harsh lines or bald patches.

3 In the far right segment, I employed soft shading. Care is needed not to exert too much pressure on the pencil so that a light tone is maintained. Ensure the tonal values within the far left and right segments are sufficiently different to enable the expression of intermediate tones in the central three segments.

4 In the centre segment, express shading somewhere between the two extremes. The tonal values between the three segments should be distinctly different, so that scope is available to express the tones remaining.

5 This is the trickiest bit of the exercise. In the segment adjacent to the dark segment, express a tone somewhere between the darkest and middle tone. At first, a difference will not be perceived until the segment has been completely shaded in. Keep checking that a difference can be perceived. Holding the paper at arm's length will help in judging tonal values.

Close up showing how pencil marks work together to suggest a particular tone.

6 The great thing about using the pencil is scope for working on top. Working in layers is key to creating the desired shading. Beware that this scope is limited. Overworking the shading or going too dark cannot be undone. This is why it is always good to start light and work darker. Here, I worked on top of the first segment, as it appeared a little too similar to the second one.

7 I moved the pencil to the segment adjacent to the palest value. Here, I exerted a little more pressure than I had in the far right. Kinaesthetic memory is built up regarding how pressure on the pencil translates into a particular tone.

8 Again, working over a previous area might be necessary to ensure each segment exhibits incremental tones that are quite distinct from one another.

Here, expressing five tones forms a good foundation onto which to practice shading technique. This can be seen from the following project.

Drawing Project 1: Shading a Dusk Skyline

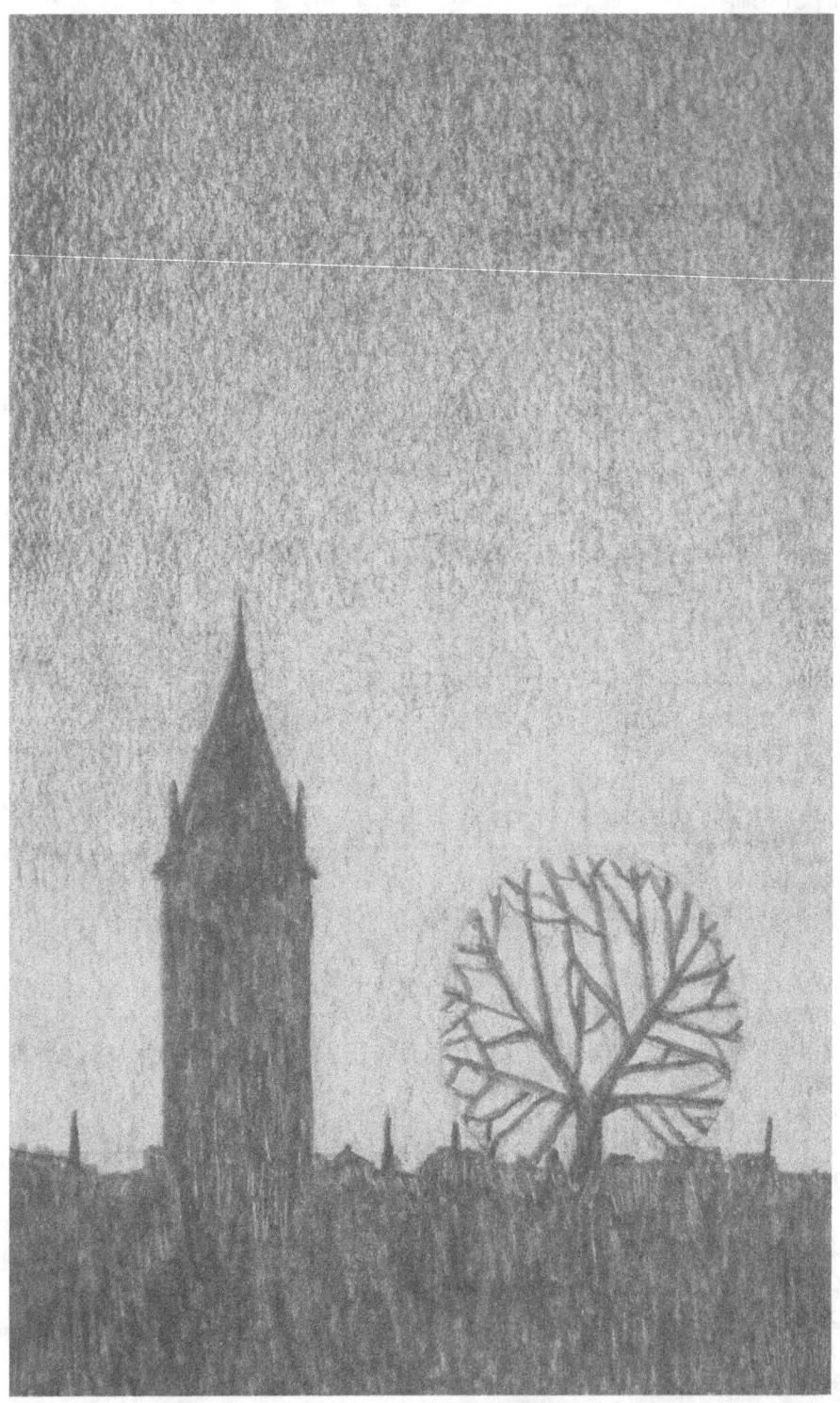

Exercises 1 and 2 have provided the setup for the first drawing project where gradation in shading is featured. A simplified skyline of a church and tree is shown here.

The drawing can be seen to comprise of two parts: a solid block of one tone, as seen on the silhouette, and gradations in tone, as seen in this sky at dusk.

This means that the theme of both the previous exercises can be practiced within one composition.

The tree is simplified, inhabiting a circular shape of definite lines. The composition will provide the stepping stone for more challenging projects.

The rounded edge of a pencil is needed for soft shading, but a sharpened pencil is needed for the outlines, spire and tree.

1: I drew a rectangle measuring 15x8cm and divided it into five segments like before. With a HB pencil, I drew a simplified church tower and tree that rests upon the first segment line. I have numbered each segment here for demonstrational purposes. The tower and tree inhabit the second segment with the roof jutting into the third.

I have emphasised the lines here as a visual aid. In fact, the lines have been drawn very lightly so that they won't show beneath the drawing.

2: In similar vein to exercise 2, I began at the top of the page with heavy shading via a 2B pencil. I worked the pencil in a fluid motion across the page and downwards.

3: Using each segment line as a guide, I worked steadily paler on moving the pencil downwards over each segment.

4: On reaching the third segment, I expressed a mid-tone akin to the middle segment of exercise 2.

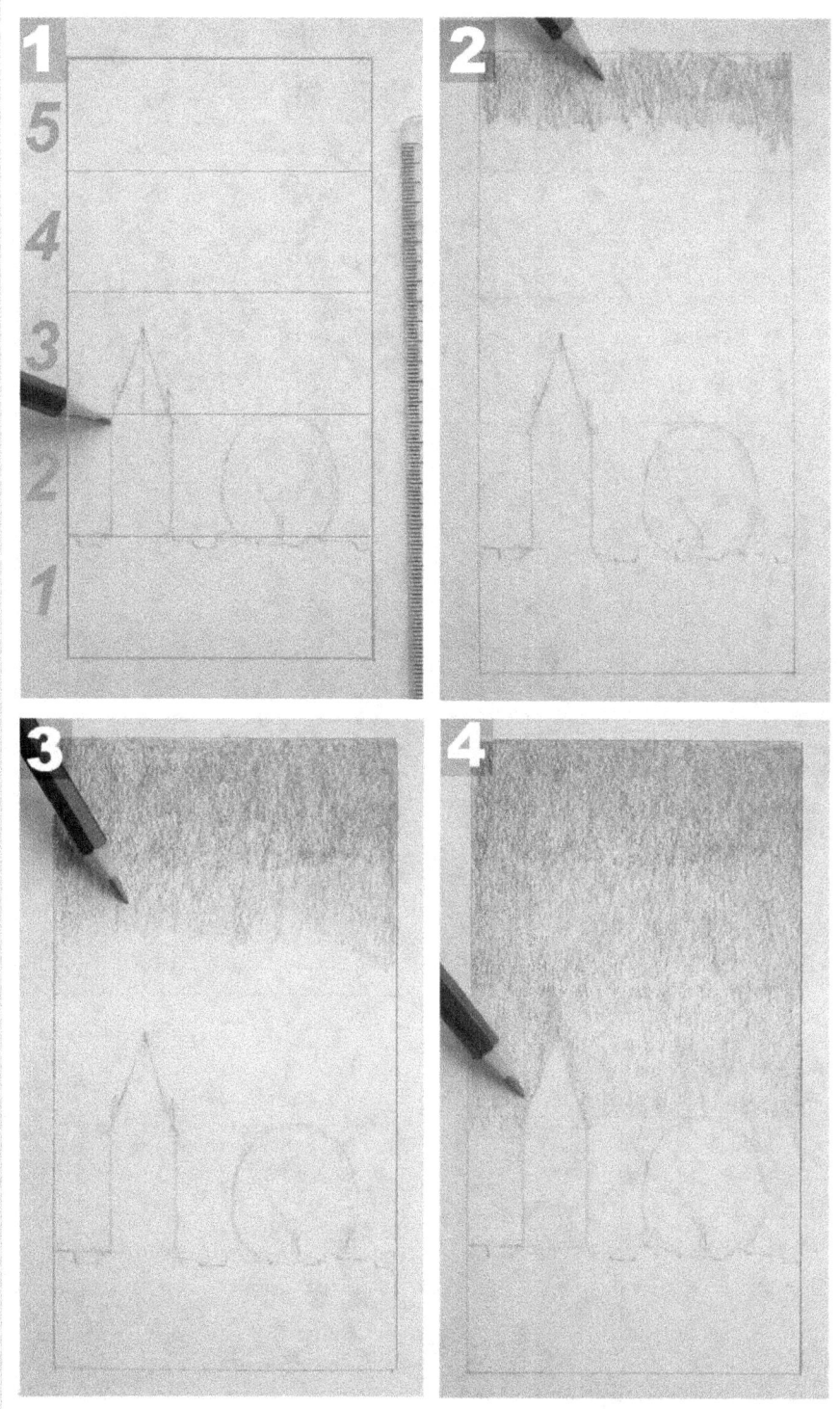

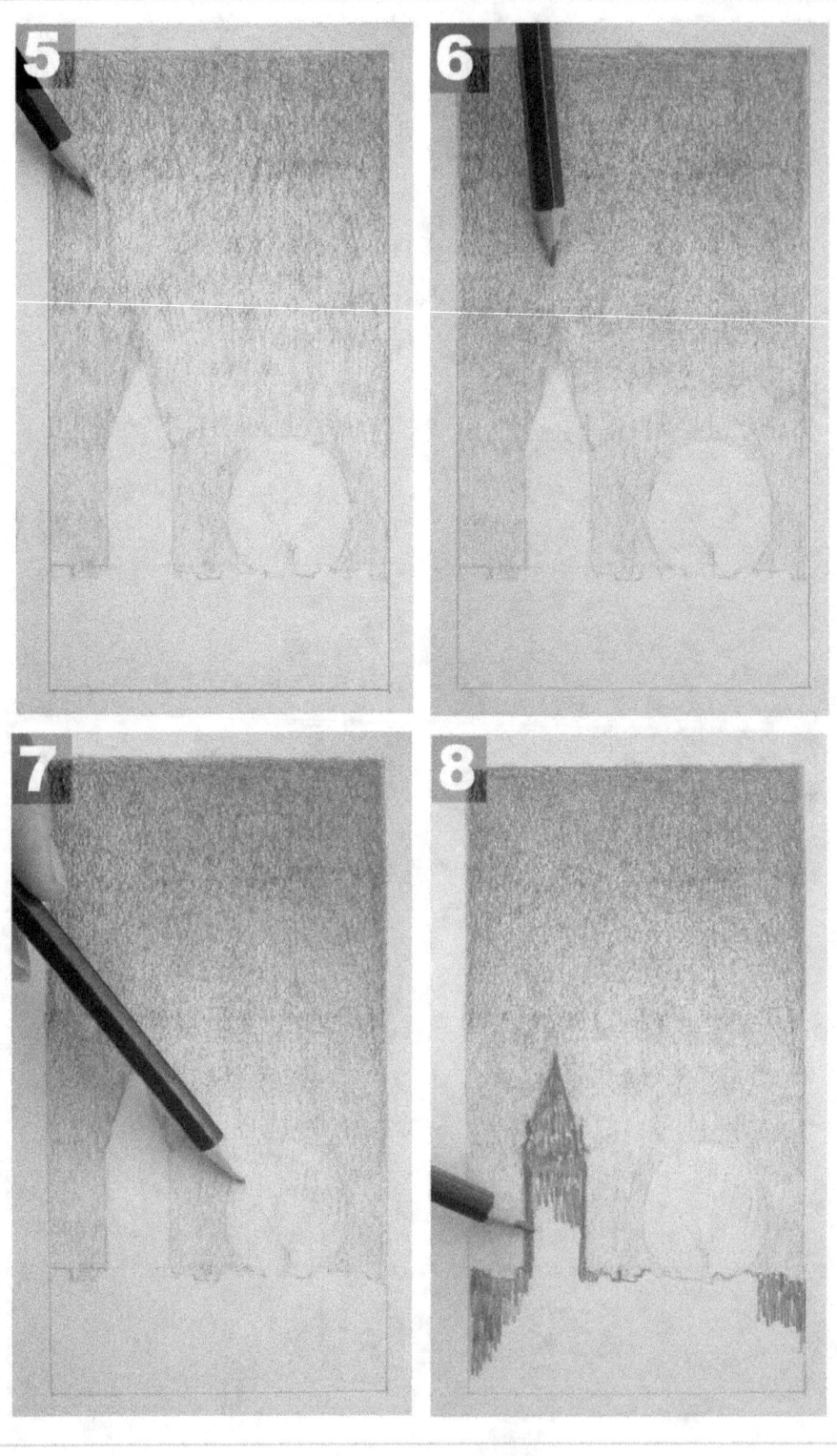

5: I worked over the segments again, shading out conspicuous marks and smoothing out rough tones, as demonstrated in exercise 1. The top segment required further darkening to steepen tonal values and heighten contrast.

6: Using softer strokes, I kept working over the sky for smooth gradations in a second layer. Watch out for overlapping shading that could create unwanted stripes, as shown in exercise 1.

7: With light strokes, I made rudimentary marks to represent the sky behind the tree. I worked lighter towards the horizon.

8: And now for the dark bits. This is a great opportunity to simply have a good scribble without worrying too much about technical detail. I moved the pencil downwards, using heavy but soft marks.

9: I continued to block in the silhouette of the church and skyline retaining even pressure on the pencil but allowing some of the page to show through. A uniform block of black is not the aim.

10: I kept the tree simplified to enable the exploration of lines. Here, the branches appear to move outwards from a basic 'Y' shape.

11: I continued to work over the branches of the tree, refining edges and creating an illustrative effect.

12: Finally, with the sharpened tip of the pencil, I expressed the spires on the church.

The effect sought after is not a draughtsman's finish or airbrushed quality, but one exhibiting marks that appear rendered via the human hand. In one exercise, tonal gradations, lines and blocking in one tone have been practiced.

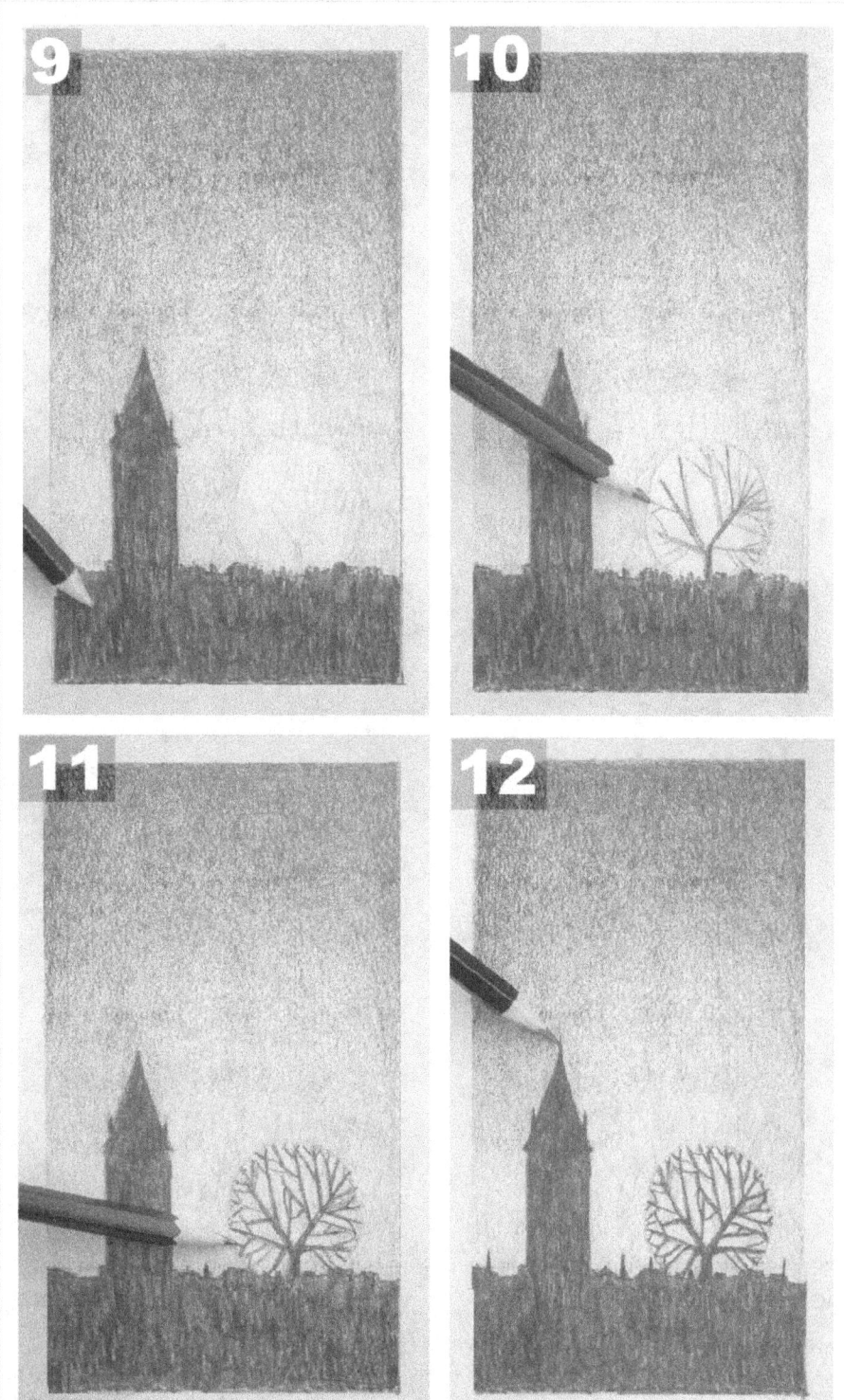

Exercise 3: Tonal Shift within a Plane

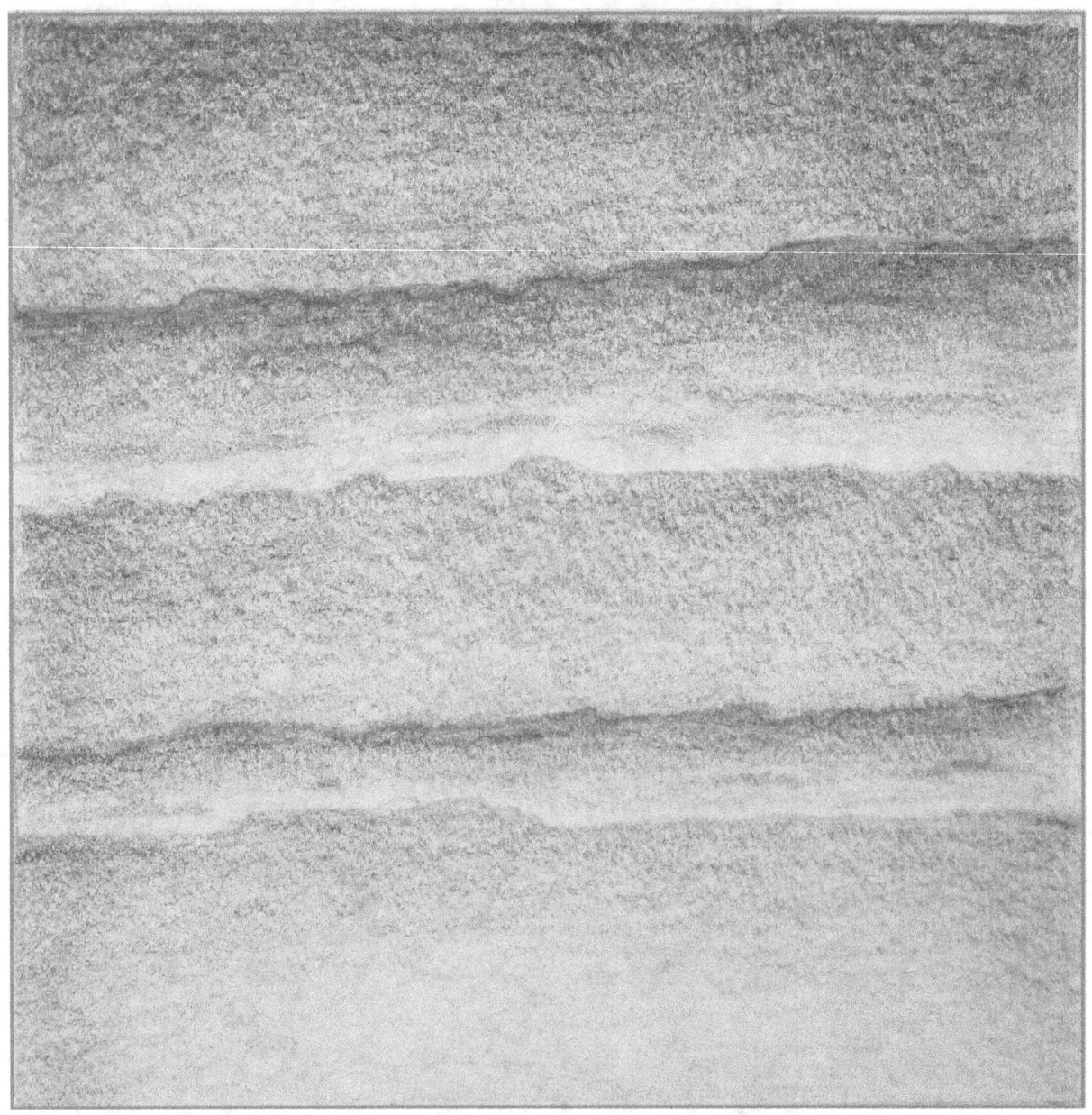

Exercise 3 provides extra challenge regarding the nature of how tones shift.

This exercise is similar to exercises 1 and 2, but tonal gradations are expressed within narrow bands against an overall background of a gradual tonal shift.

The result will suggest banner clouds against sunset, providing the setup for Drawing Project 3: Stonehenge at Sunset.

Additional challenge is provided in the highlights of the clouds where shading is avoided. Textures are also suggested.

1: Within a square measuring 10cm, I drew 4 horizontal lines that waver in places as shown. These simple lines will represent the clouds. Via a 2B pencil, I shaded the uppermost area of the cloud nearest the zenith.

2: I faded the shading out steeply, allowing streaks to remain. This will suggest contours in the clouds.

3: I moved to the second banner cloud, beginning dark and shading out more steeply than on the first cloud.

4: For the background sky. I began with a dark tone at the zenith, lightening out a little so that the tone ends up paler than the shadow of the upper banner cloud as shown.

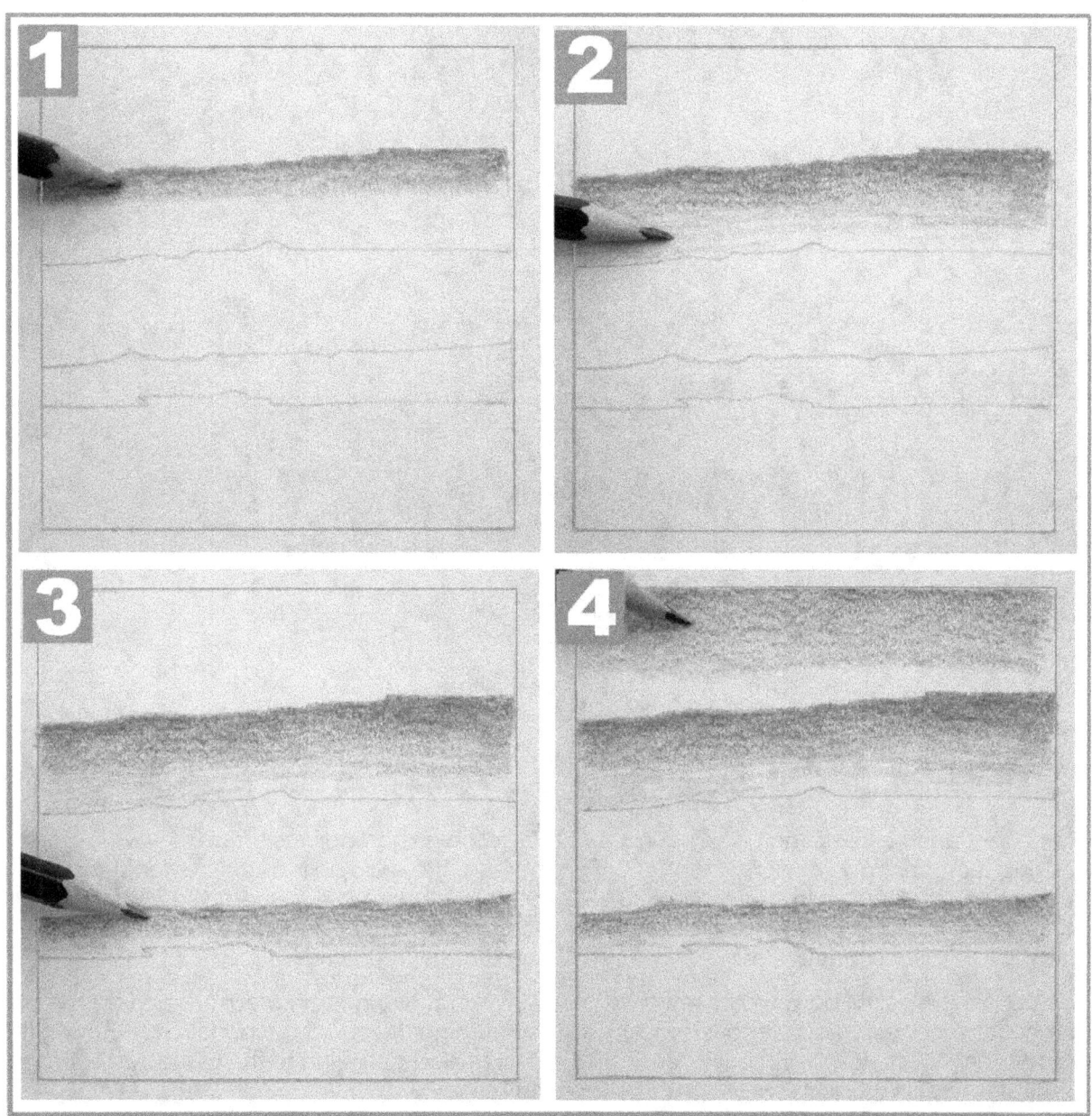

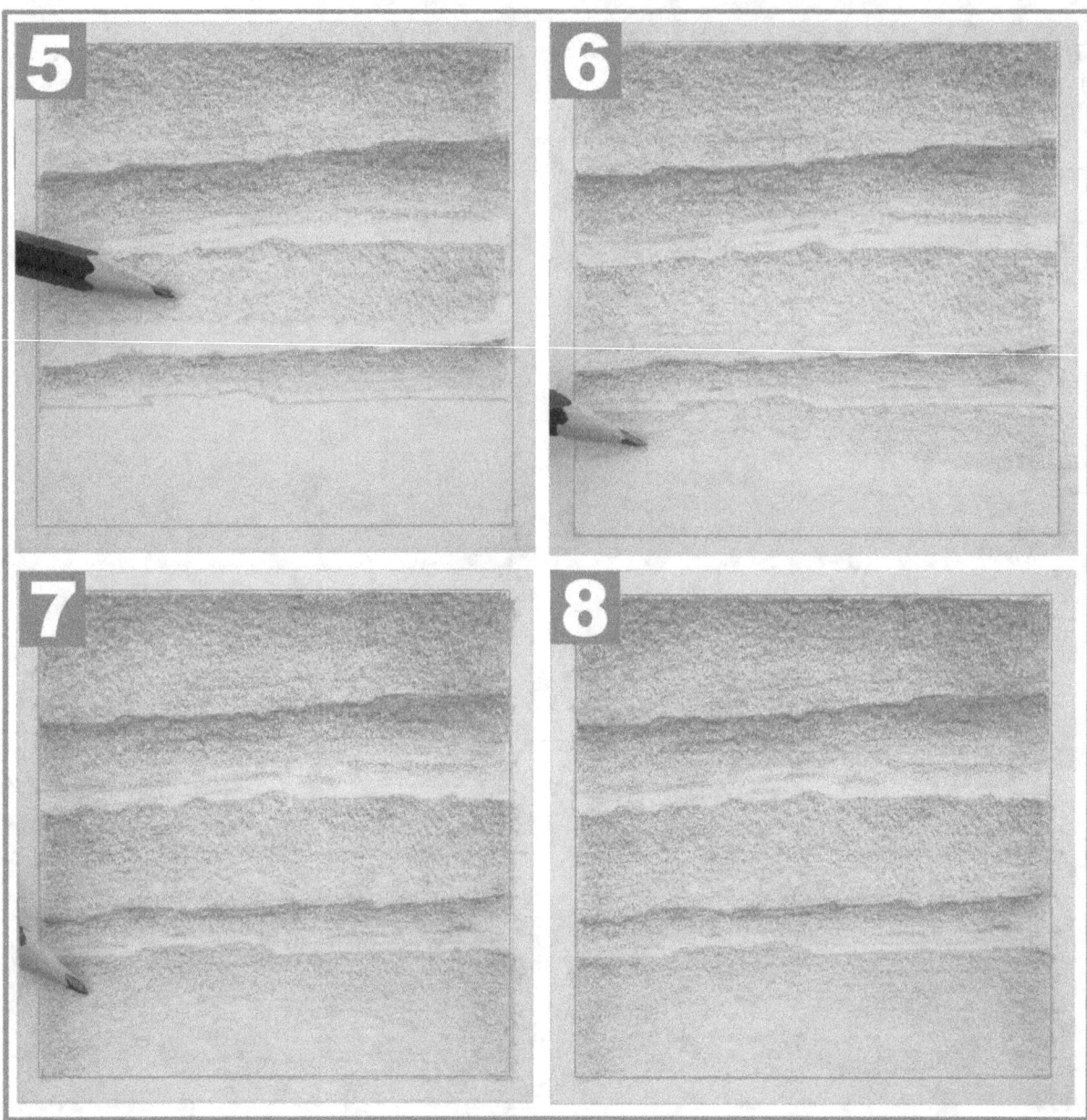

5: I continued to express the background sky, moving the pencil downwards past the upper banner cloud whilst shading out. Notice how the tone shifts more gradually than on the clouds themselves.

6: I moved the pencil downwards towards the horizon, achieving a pale tone to suggest sunset. The clouds now stand out in stark relief against the softly graded sky.

7: Delicate shading was required towards the horizon. The shading is a little darker at the edges of the square to suggest a single light source from the central base line. This will be the sunset.

8 Working over certain areas will perfect the tones. Here, I worked the pencil over the zenith and added definition to the clouds via soft outlines.

Exercise 4: The Negative Space of Stonehenge

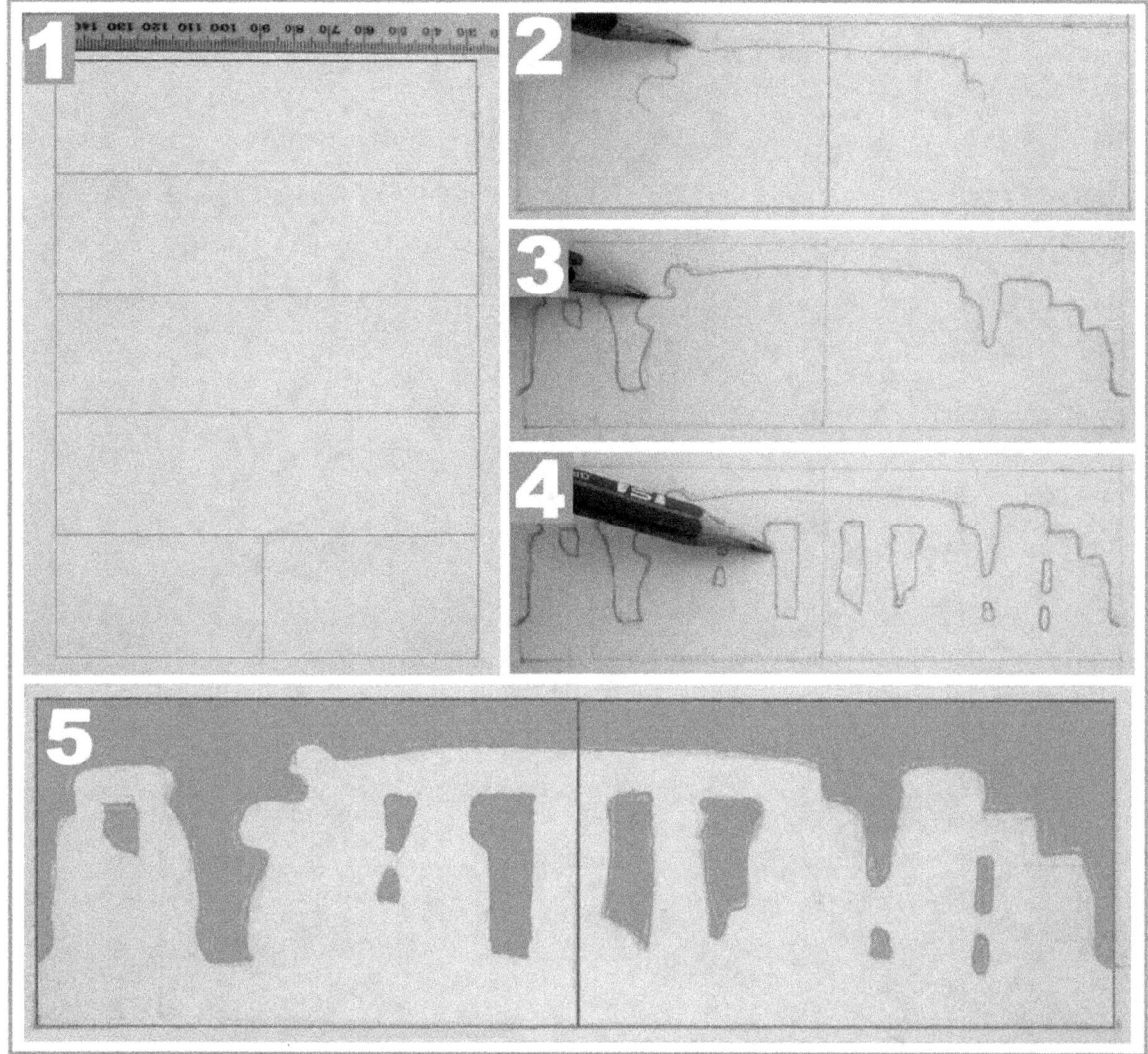

Stonehenge is a prehistoric stone circle in Wiltshire, England, providing the ideal subject matter for exploring negative space, the topic of this exercise. Negative space is the background shape around objects as opposed to the object itself.

The aim here is to draw Stonehenge's outlines freehand, ready for Drawing Project 2: Stonehenge at Sunset. Notice interesting abstract forms such as oblongs and globules, which fit into a rectangle. Don't worry if negative space seems challenging. Exercise 5: The Framing of Negative Space shows how to anchor these shapes down as well as differentiate between their qualities.

1: I drew a rectangle 18x12cm and subdivided it into five sections as shown. The bottom segment has been split in half to make the Stonehenge drawing easier. The gridlines have been emphasized here as a visual aid.

2, **3** and **4** show how Stonehenge has been drawn within the bottom segment. The central line has been used to help plot the drawing. Notice symmetrical elements of the monument. **5** The negative space has been darkened here to bring negative spaces into the forefront.

Drawing Project 2: Stonehenge at Sunset

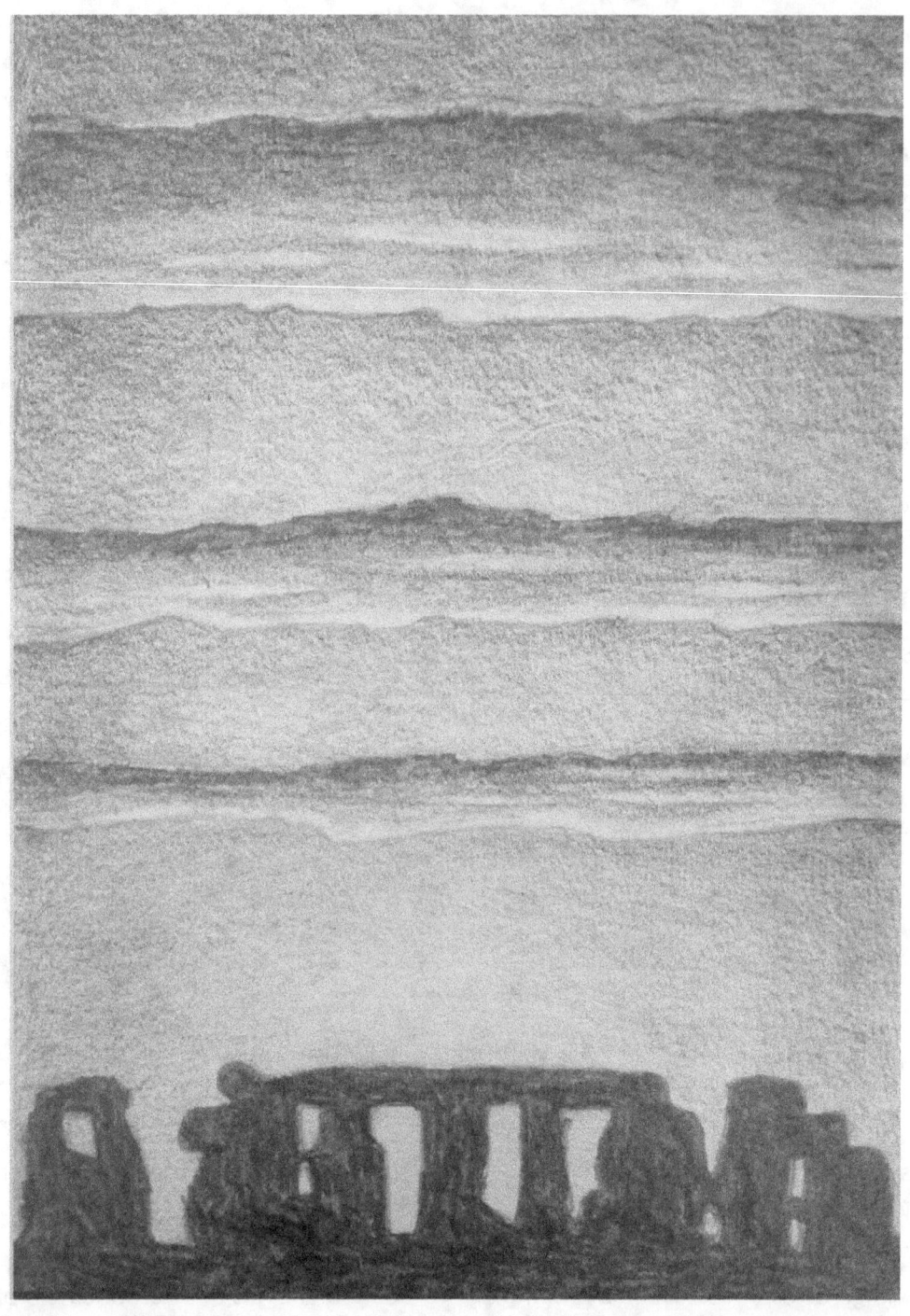

Exercises 3 and 4 have provided the setup for this drawing of Stonehenge at sunset with consolidation of exercises 1 and 2. The completion of this project now seems more achievable – a natural progression from the previous project.

1: The image shows the gridlines emphasized and how they support this exercise. Stonehenge has been drawn out within the bottom segment during the previous exercise, and the four upper segments permit ample room for expressing a dramatic sky.

I drew out three bands of clouds via six horizontal lines that waver in places. These will represent the banner clouds, as expressed in exercise 3.

2: Again, the background sky exhibits a gradual tonal shift against clouds with steep gradations. This will create drama against Stonehenge. With a 2B pencil, I began at the zenith, expressing dark, but not too heavy shading, working downwards.

3: I then worked the pencil past the upper banner cloud, easing the pressure off a little as I worked towards the horizon.

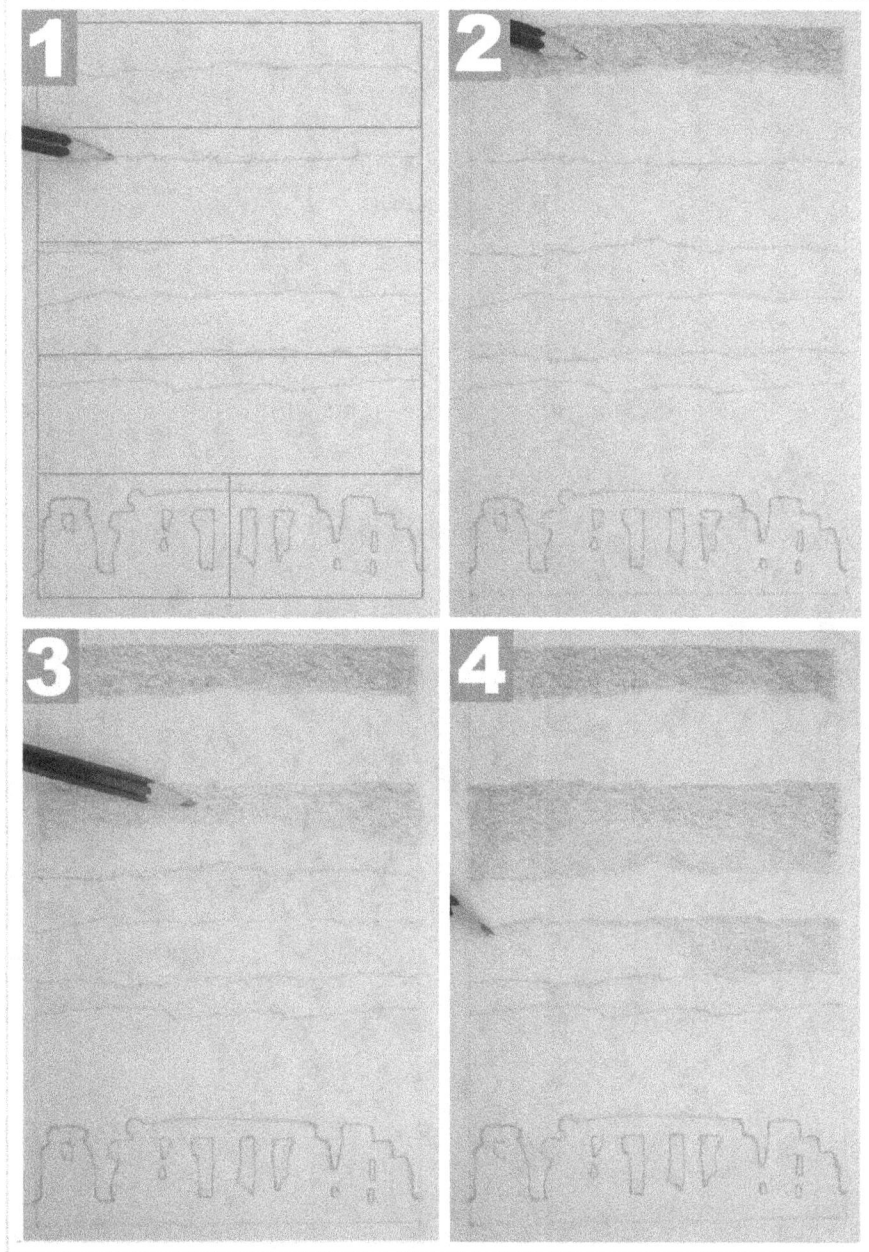

Be careful not to work too dark at this stage or little scope for modification will be given.

4: I worked past the second banner cloud, ensuring the tone steadily eases off as I shaded towards the horizon. The third and fourth breaks will exhibit ever lighter tones between the banner clouds. Additional challenge can be found in the third banner cloud, not present in exercise 3.

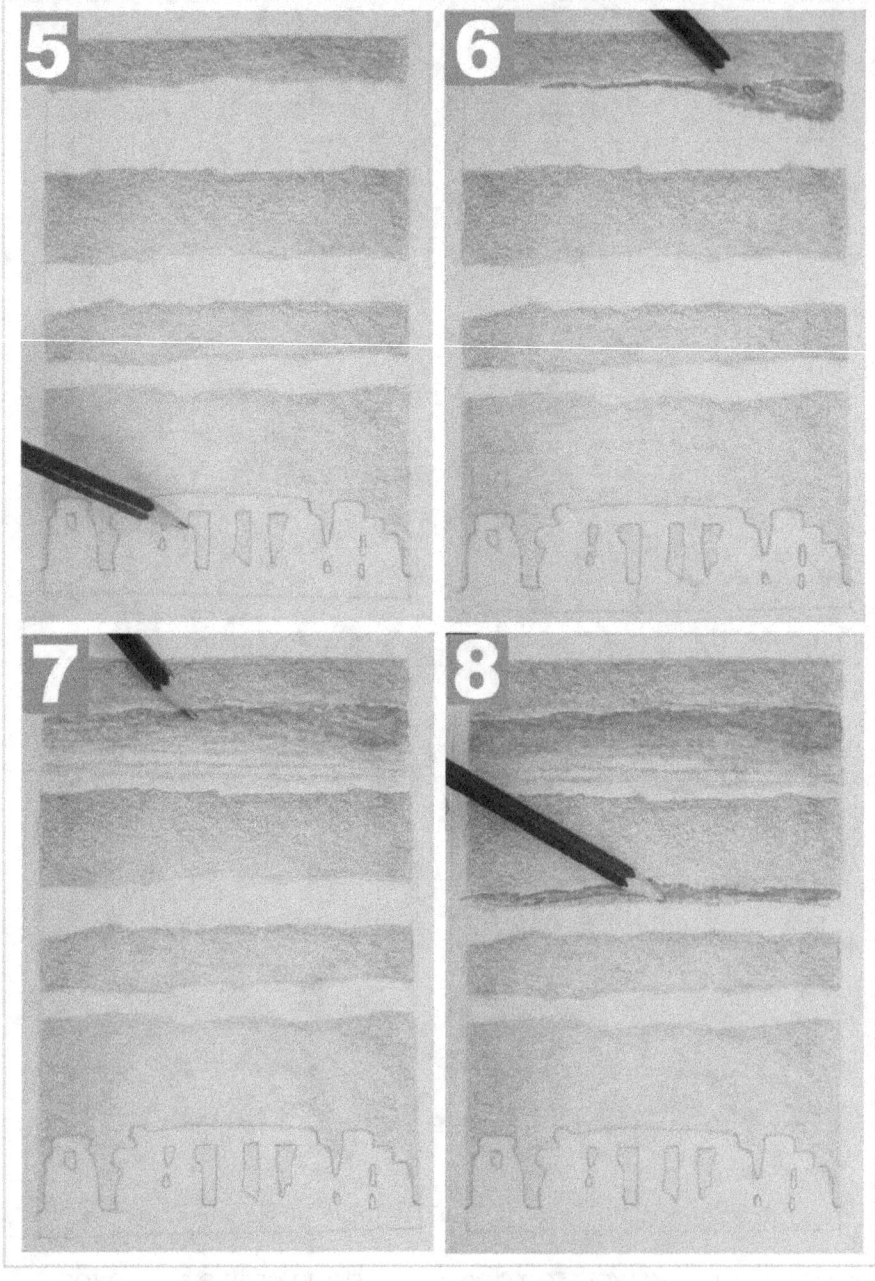

5: The sky within the negative spaces of Stonehenge will provide the palest area of the drawing. Keep the pencil light and shade on the far left and right of the composition to suggest a single light source in the centre. The palest area of the drawing will be the sky peeking between the stones.

6: And now for the clouds. I expressed heavy shading on the upper edge of the first banner cloud, easing off abruptly further down. This will suggest sunlight hitting the base of the cloud. Keep in mind the overall tonal shift of the sky.

7: Horizontal streaks were expressed within the highlights to suggest the texture of melting clouds. Be careful not to express these as mere lines, or the harshness will fail to convey an ethereal feel. Work softly initially to ensure the tones key into the rest of the sky.

8: I worked similarly on the second banner cloud, creating a progressively steeper tonal shift upon the base as they encroach upon the horizon. The clouds closest to the zenith will appear more diffuse due to the vantage point.

9: I shaded out from these dark streaks, leaving pale bands untouched. This will suggest soft pleats in the cloud base. I progressed onto the second banner cloud, expressing these ghostly streaks a little closer together due to the perspective of the sky.

10: The third banner cloud is the narrowest of all and therefore would exhibit the steepest tonal shift. This will suggest clouds receding into the distance. As before, I suggested pale bands and dark pleats. Although not the main subject matter, these interesting textures provide the setting for Stonehenge.

11: Once finished with the sky, I applied heavy strokes to the stones themselves. Notice high contrasts between the sky and the silhouette, reinforcing Stonehenge as being the focal point of the drawing.

12: The aim is not solid black, but heavy shading that on close up exhibits scrawls and squiggles.

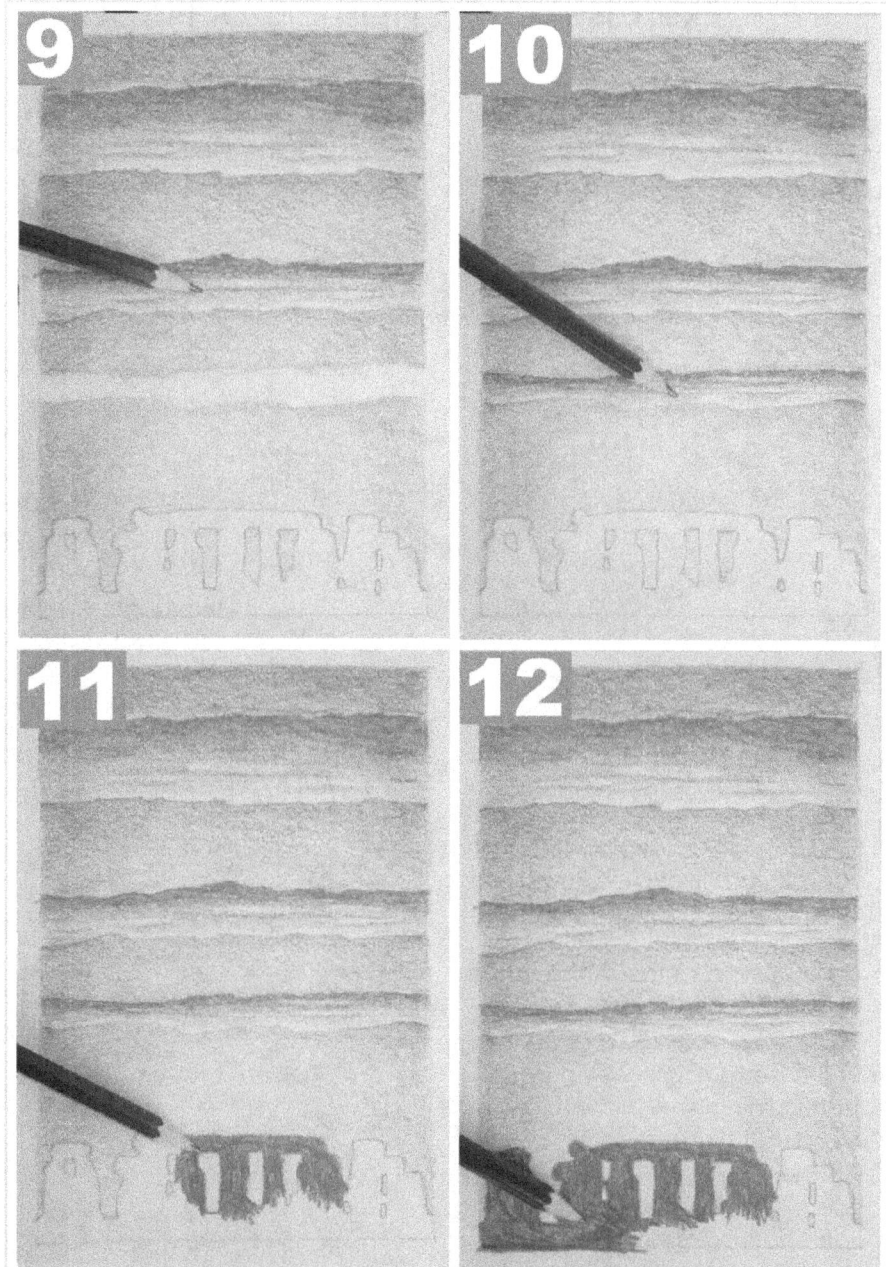

Here, I worked the pencil into the direction of the stones, resulting in pleasing textures and a multitude of marks. Keep the pencil lines free but with some control.

This exercise provides basic freehand drawing via the rendering of negative space; the expression of incremental tones and textures. These techniques will be revisited throughout this book with increasing challenge.

Exercise 5: The Framing of Negative Space

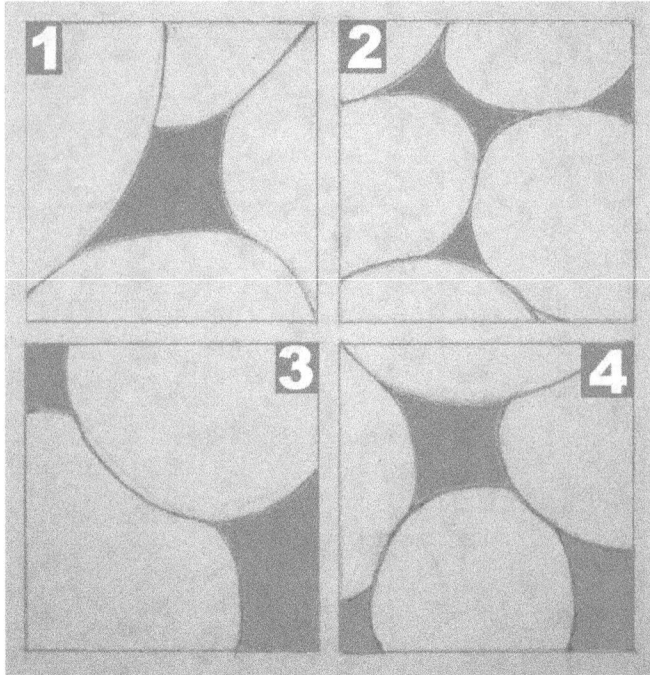

This exercise provides the setup for Drawing Project 3: Beach Stones.

The composition exhibits odd triangle and diamond shapes when the stones are placed together. Shapes between objects are known as 'negative space', (as explained in exercise 4). The objects themselves are the positive shapes.

The key to accurate drawing entails drawing both simultaneously. It's like drawing a jigsaw with the missing pieces at the same time. Anchoring negative spaces and positive shapes is made easier when placed within a square or rectangle as shown here. Each 'frame' measures 5cm.

In order to explore negative spaces, I have provided images showing negative spaces of varying challenge. Notice how one shape can be anchored to another via linking lines. The first grid of four shows the negative space darkened. The second grid of four shows the positive shapes darkened. Both can be used as a drawing aid. Shading is unnecessary but can be practiced if desired.

1: The first image shows how negative space can be pinned down via linking lines. Notice a contour slashing diagonally from the upper right to lower left of the image. A kite shape interrupts it.

A similar line curves towards the centre from the bottom right where an opposing line curves midway towards the upper section.

2: Here we can see three negative spaces. Two of them are triangular in shape. The third resembles an egg-timer. Notice how one relates to the other regarding size and their position via linking lines.

3: The negative spaces are bold here, nestling into adjacent corners via a curved linking line.

4: The negative space resembles image 1, but in reverse. Notice additional negative spaces in the bottom corners.

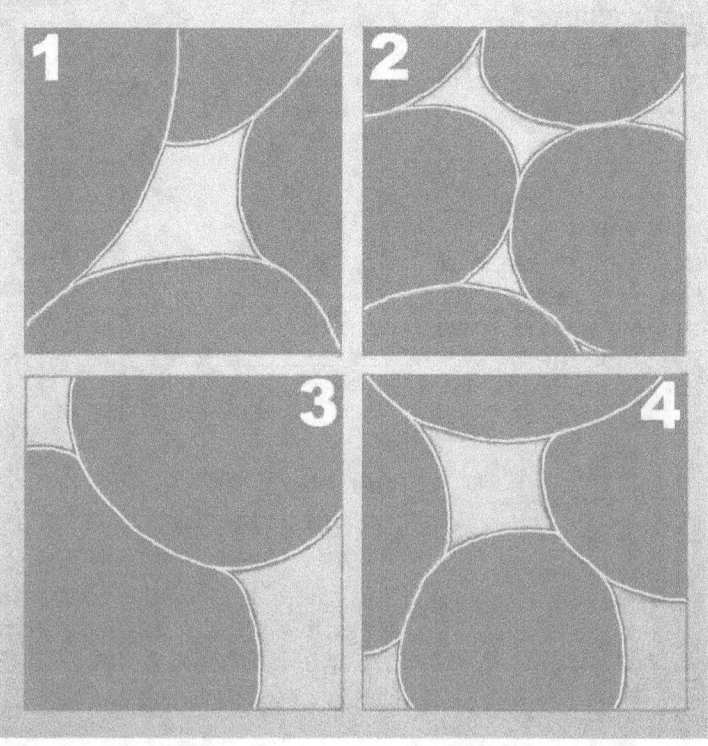

And now for drawing the beach stones. As can be seen here, an array of negative spaces can be seen. It may appear overwhelming at first.

But bear in mind the previous exercise. Take a look at the two images below which show the negative spaces darkened and then the positive shapes darkened.

Notice each section resembles some of the shapes drawn in the previous exercise. Each shape can be anchored into the other via linking lines.

Observe how these shapes relate to one another within the frame. The frame makes each shape more obvious.

This is the secret to accurate drawing: awareness of positive and negative shapes within a frame. Take note of size, placement and how each shape link to one another.

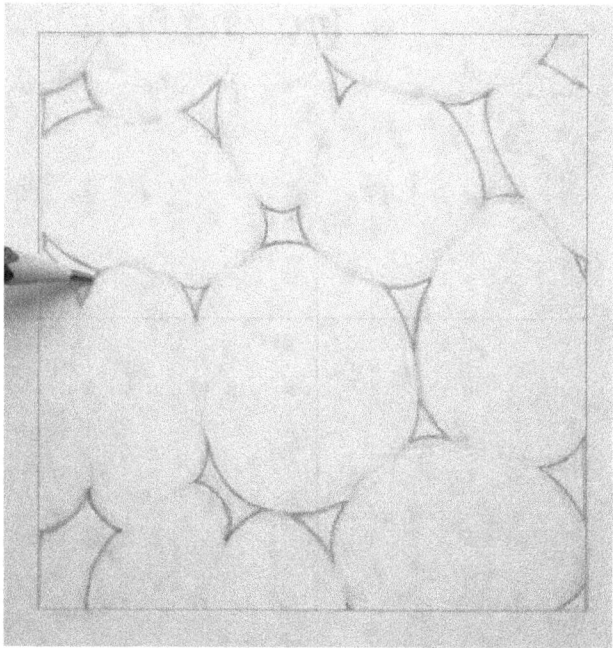

I have drawn a 'frame' measuring 11cm square in which to conduct the drawing. I have then divided the square into four. This makes the drawing manageable. The lines have been emphasized here for visual purposes, but needs to be faint on the actual drawing. As always, begin pale with the pencil before working a little darker.

An eraser can still be used for fine adjustment. Be as accurate as possible before working on the next stage.

Make sure each shape fits into the composition as shown. As can be seen, the frame and the 'cross' can be used as a means of plotting these shapes.

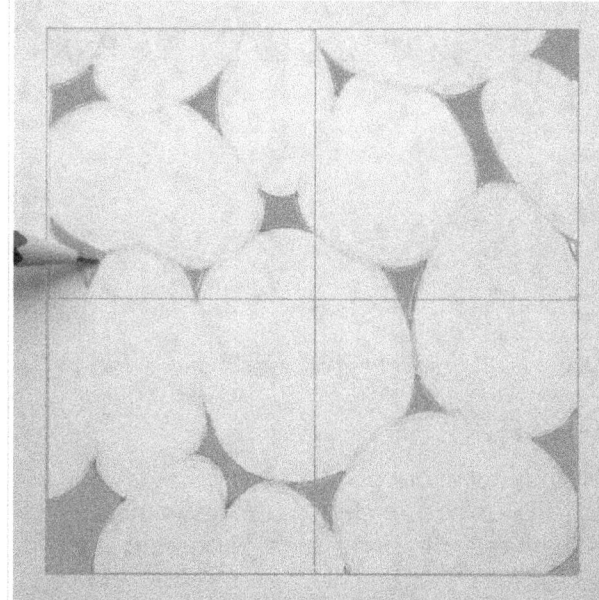
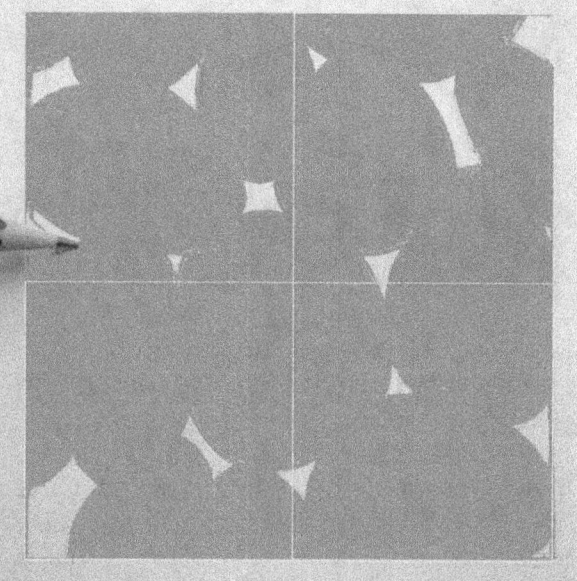

Drawing Project 3: Beach Stones

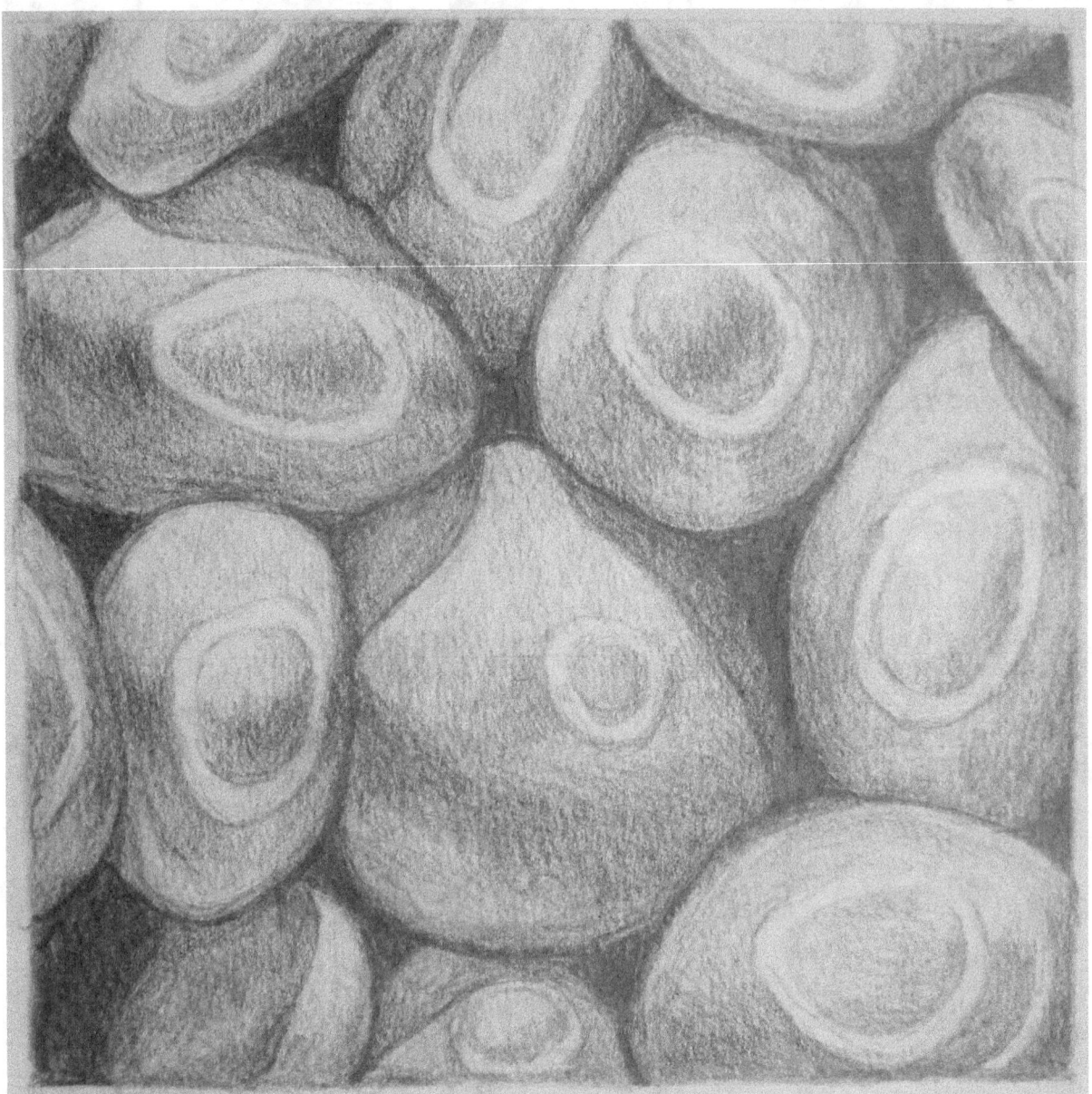

These beach stones provide the perfect opportunity to practice an array of shading within bold shapes. Here I have selected a dozen or so stones on the beach and laid them in full sun before taking a photo. Odd 'halo' formations on their surfaces provide added interest.

Various shading techniques have already been practiced. Here, suggesting egg-like formations is the focus.

Notice how tones shift in organic curves. Some vanish into deep shadow; others exhibit reflections from neighbouring surfaces.

Framing the Picture

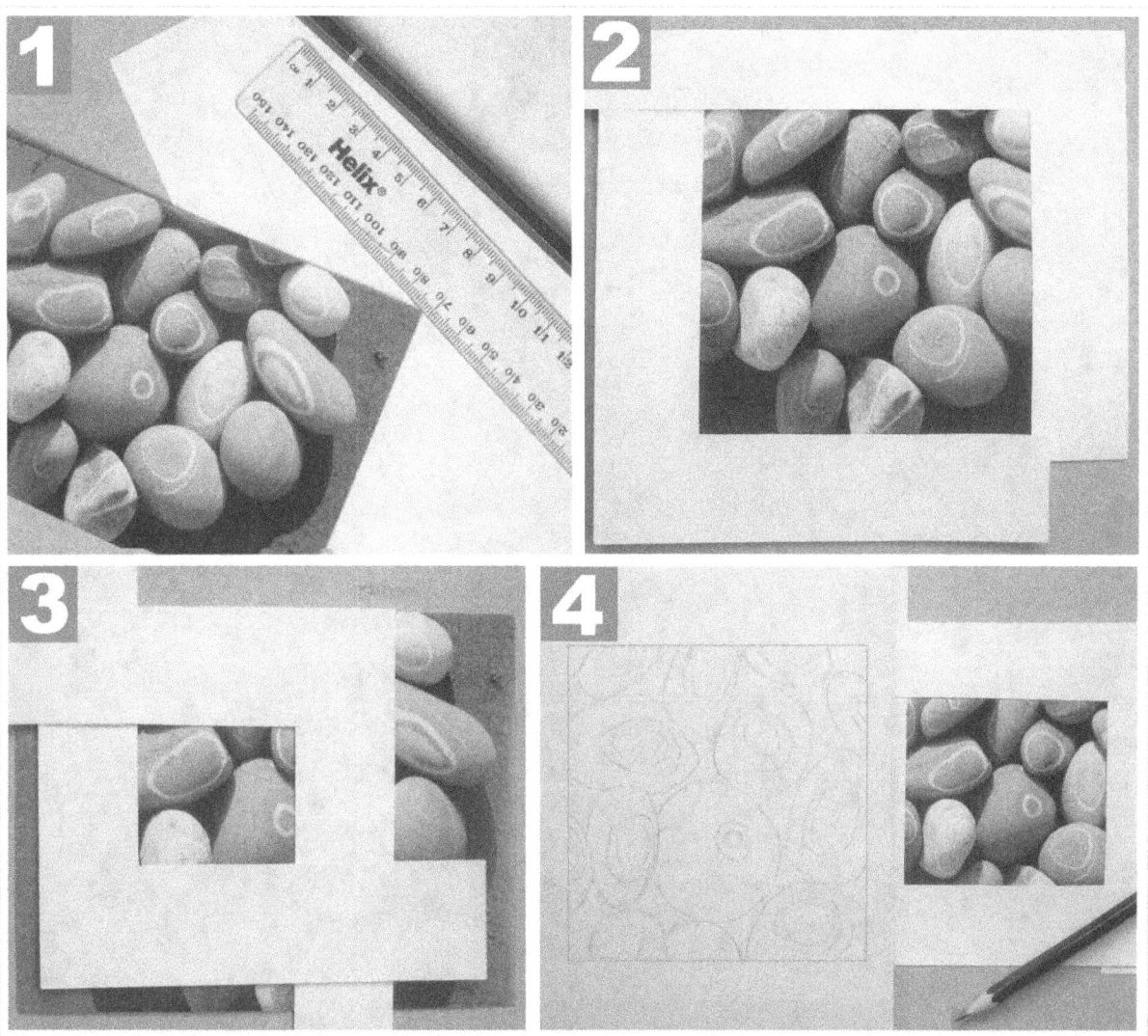

1: The composition for this drawing was created by the use of an adjustable frame. Interesting compositions from photographs is made easy. Here, I have cut two pieces of card (paper will do) into L-shapes 12cm on each side. As can be seen from images **2** and **3**, the L-pieces can be placed over a photograph and moved inwards, outwards or in any position desired.

The composition can be square, rectangle, portrait or landscape format.

I adjusted the two L-shapes so that an interesting portion of the photograph is revealed.

Here, I decided upon a square composition of beach pebbles with interesting bands and shadows. The subject matter comprises odd abstract shapes that permit freedom with expression.

4: About a dozen beach pebbles are revealed in the image. This makes the drawing easier, as unwanted elements can be edited out before the drawing begins.

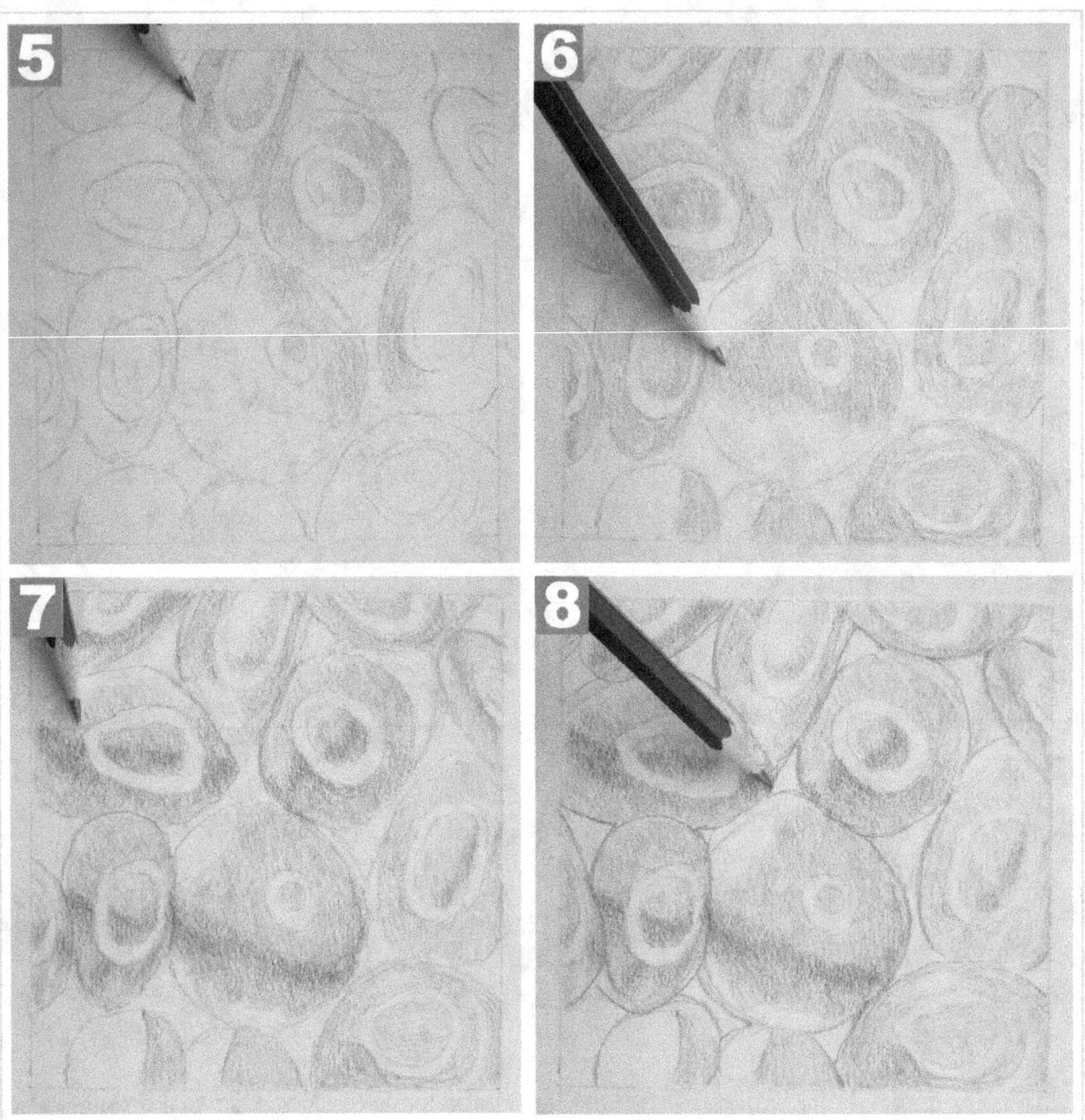

5: The outlines of the stones have already been drawn in exercise 5 when exploring negative space and positive shapes. I used a 2B pencil to express a flat mid-tone. I was careful not to go over the halo-shaped blemishes on the stones' surfaces.

6: I continued to shade this flat tone in the manner of exercise 2 when filling in the middle-tone on the grid – neither too pale nor too dark. I kept the lines soft, using the edge of the pencil.

7: Notice bands of shadow across the stones' surfaces. This is where sunlight and reflected light meet. I expressed these odd bands, keeping the edges soft and noticing how some take on various forms.

8: Next, I refined the irregular triangle-shapes between the stones. Modifications are always needed, so I worked darker and with increasing accuracy.

9: I kept checking the stones' outlines for accuracy before shading them in. Notice how the odd triangles vary in size and dimensions. Each informs upon the stones.

10: I created soft edges to the shadows to avoid a cut-out, flat feel. I then moved onto the shadows cast on the stones' surface. Notice the abstract shapes these shadows create. Unlike the triangle shapes between, the shadows on the stones possess variations in tone.

11: Once I was satisfied with the overall look of the drawing, I will work darker, reinforcing shadows and refining outlines. I emphasized the shadow-bands to create a three-dimensional feel to the stones.

12: I refined outlines, working around the odd 'haloes'. I then applied light shading to the darker sections of these ring markings, to reinforce the spherical quality of the stones.

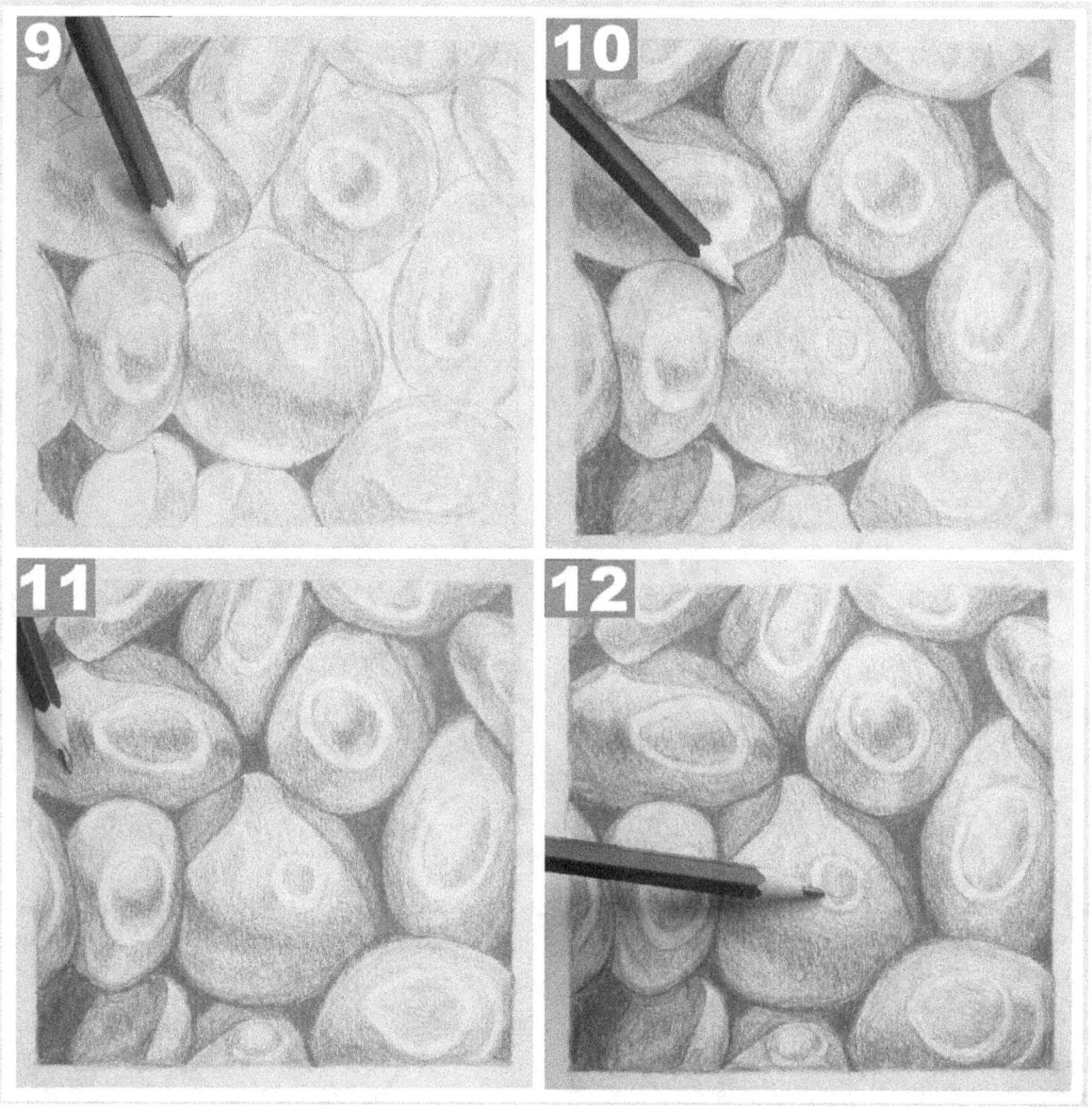

Exercise 6: Drawing Symmetrical Shapes

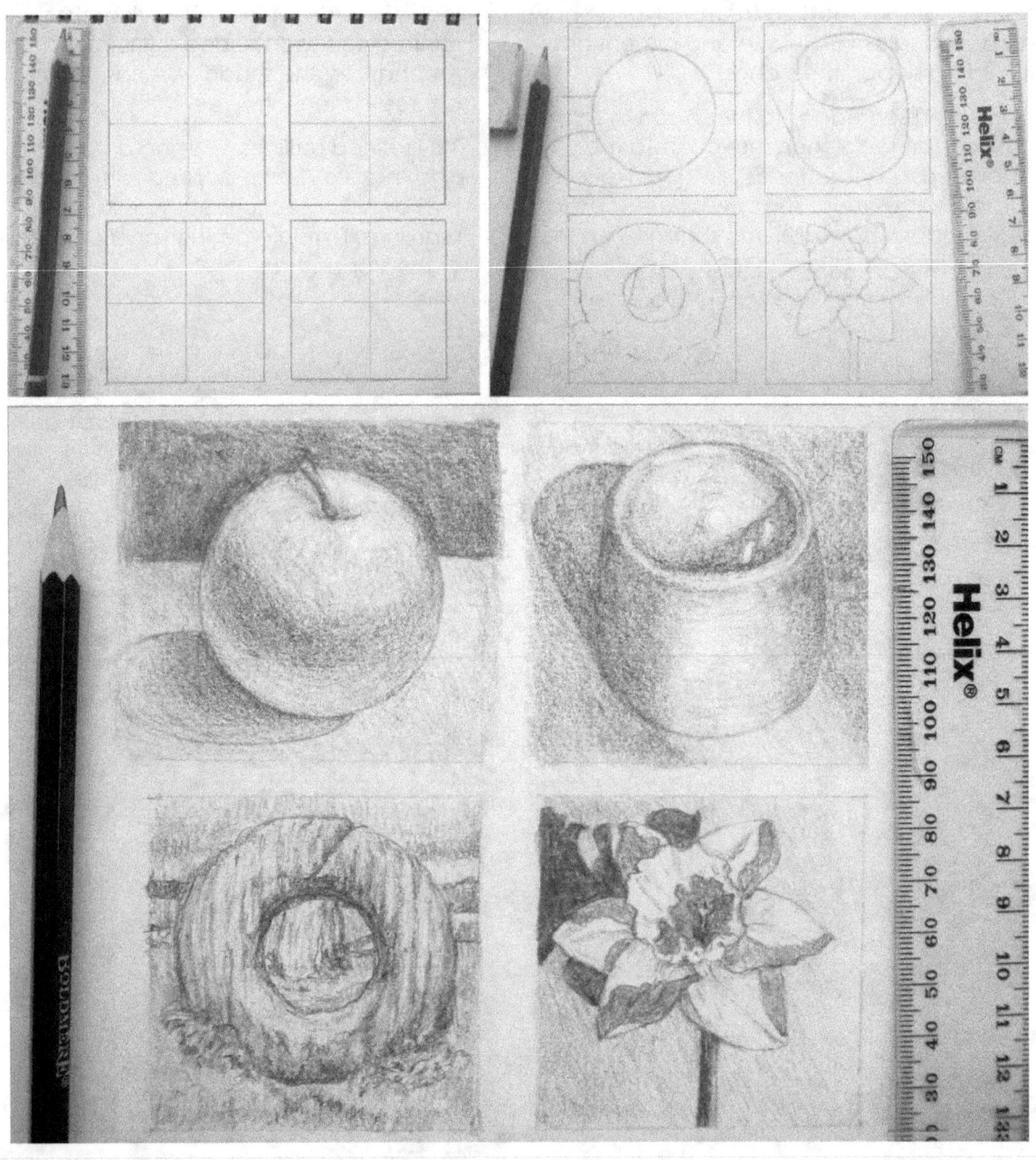

Drawing symmetrical shapes is a great way of improving drawing skill, for it exercises all four fields of vision. Here I have selected four symmetrical objects, some more straightforward than others. The drawings should take around 15 minutes each. The exercise begins with an apple, for it is based upon a spherical form.

Next is an eggcup. The third image shows the doughnut-shaped Men-An-Tol standing stones near Penzance, UK. Finally a daffodil head. On A5 sketch paper, I drew four squares measuring 6cm each and divided them into four quadrants as shown. The lines are emphasized here for visual purposes.

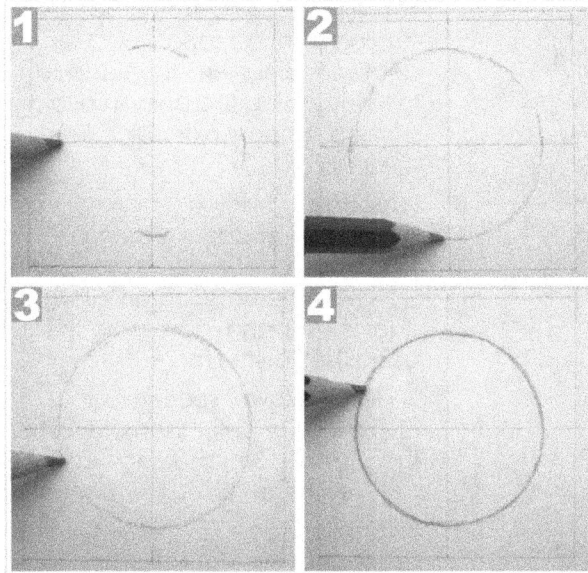

For the apple, I drew a circle freehand. This is not as easy as it sounds but the gridlines drawn earlier will serve as a guide. I made 4 elementary marks, equal distance from the edge of the square. I then joined them up via curved lines, turning the page upside down to reveal deviations. I Worked gradually darker as shown.

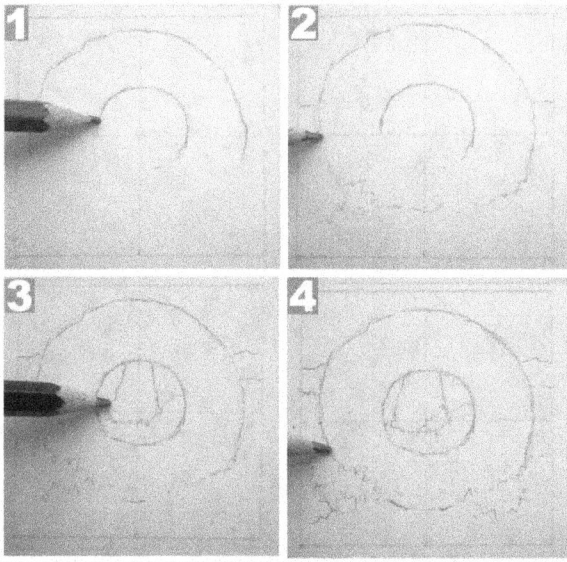

The Men-An-Tol's doughnut-like fore-stone need not be so perfect, but again exhibits symmetry. I began with the inner circle of the doughnut, rendering it dead-centre of the drawing. I then expressed the tree-line and grass.

For the eggcup, I drew a wide ellipse in the upper half of the square and made a mark near the bottom of the central line. I then pulled down the edges of the eggcup, rounding off to a flat base. As always, ensure both sides of the object mirror one another. I then drew an inner ellipse to suggest depth.

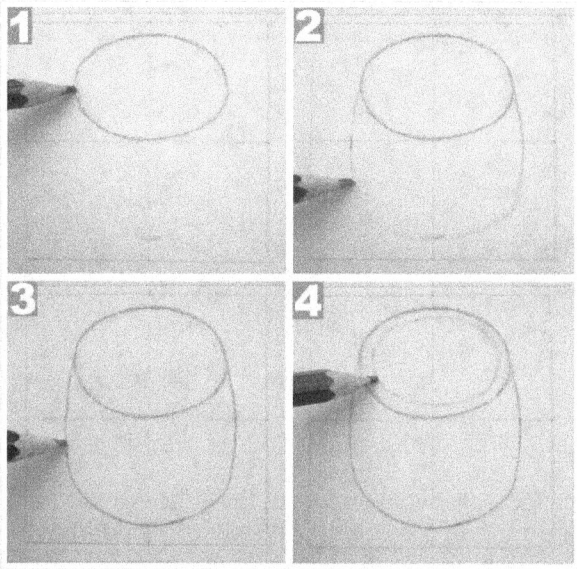

Due to the angle, the daffodil head deviates from symmetry, but the petals diverge from the central stamen in similar fashion. The stem is placed slightly to the right and I worked basic detail onto the petals.

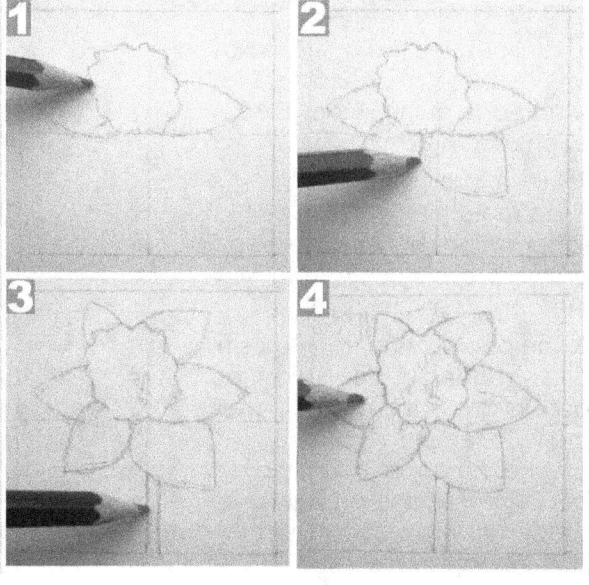

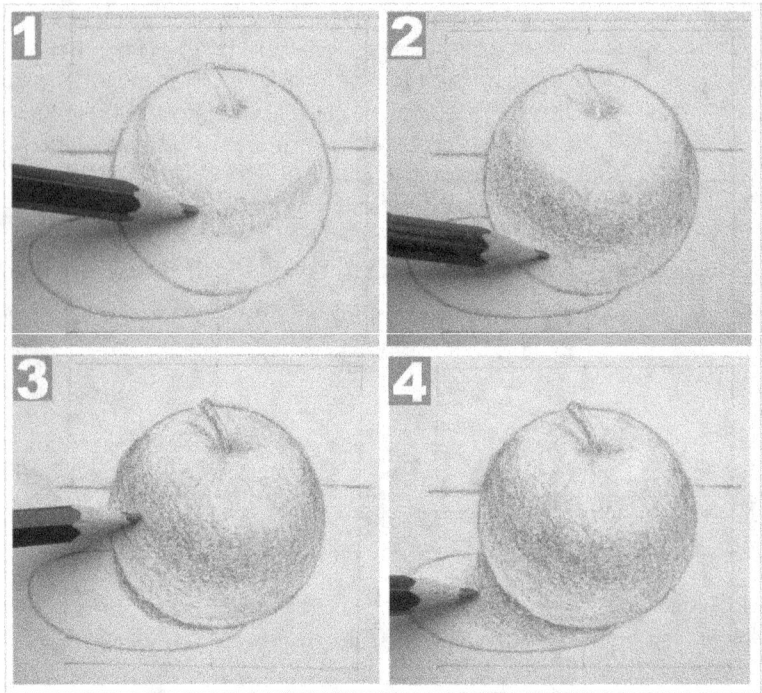

1: The apple has been drawn starting with the sphere completed earlier. I then added the stalk, table top and an ovoid-shaped shadow extending from the left.

I began by shading a dark curved band running approximately across the centre of the apple. I worked softer shading on either side of this band, darkening the band itself a little more.

2: I left the lower section of the apple slightly paler than the rest of the shadow. Soft shading was required here.

3: I lightly shaded in the rest of the apple, leaving highlights untouched. I then began on the shadow on the table top, beginning with the darkest area.

4: I expressed the apple's shadow, working outwards and decreasing the pressure. Although the shadow exhibits tonal gradations, the palest area will remain darker than the rest of the table top.

5: I continued to shade outwards from the base of the apple until the edge of the shadow is reached. Working over an area again might be necessary in order to achieve smooth shifts in tone. Notice, the shadow upon the table top becomes paler and softer with distance.

6: I shaded the rest of the table top, employing fine strokes. The worn edge of the 2B pencil has been used here.

7: I then worked the pencil once more over the apple, softening harsh lines and steep gradations in order to suggest the apple's spherical shape.

8: The background can now be briskly shaded in. Don't work too dark initially but allow the pencil marks to remain. I worked around the apple, taking care at outlines. Notice highlights suddenly stand out against the dark background.

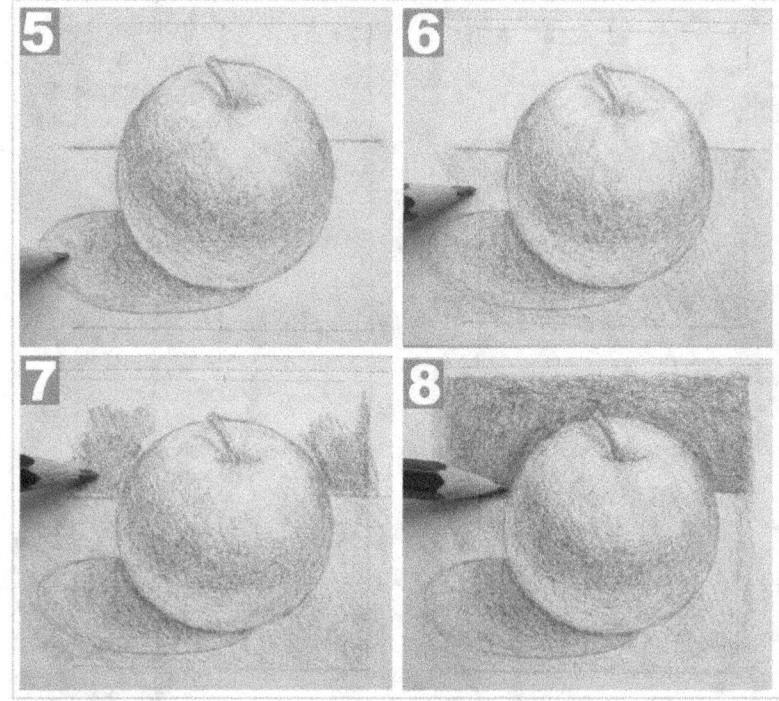

1: The eggcup has been drawn out earlier. Here, I began with the crescent-shaped shadow nestled within the cup. Shading was applied fairly dark here, omitting two areas of highlight on the right.

2: I then worked on the far left of the cup. The shadow gradually fades out towards the centre. A cylindrical shape produces shadows of vertical formations as opposed to curves, as seen on the spherical apple.

3: I expressed shading on the corresponding side of the cup to complete the cylindrical effect. The central area was left blank for the highlight.

4: I began shading the inside of the cup, leaving a blob of highlight in the centre. Soft shading was achieved by moving the pencil in semi-circular strokes. Care is needed not to go over the lip of the eggcup.

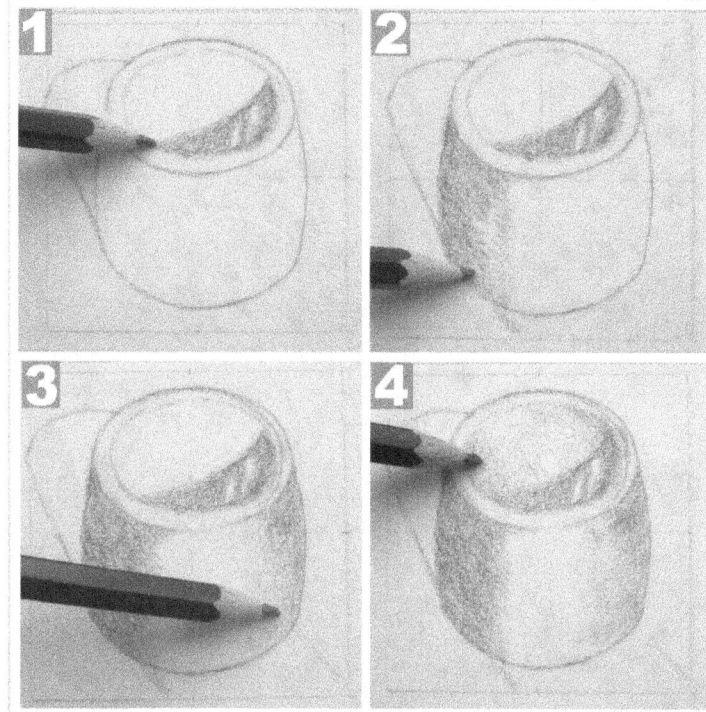

5. The cylindrical form of the eggcup was then refined. I brought ever softer shadows to the centre of the eggcup's front, where a band of highlight can be found.

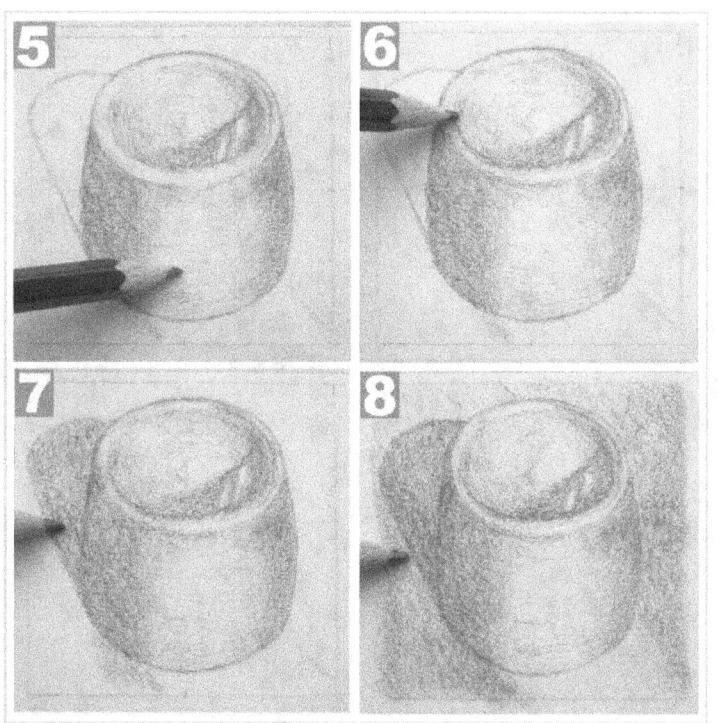

6: Once the eggcup has been shaded, I softened the edges of the ellipse to suggest a rounded surface. I also darkened select sections of the ellipse to suggest light waxing and waning.

7: With the ellipse done, I worked a solid area of shadow behind the eggcup. I considered the shape akin to half an inverted teardrop. I worked the pencil in diagonal strokes from the base of the cup with fairly dark marks. The eggcup now appears to inhabit space.

8: The background exhibits various areas of shadow from a window. This echoes where shadow falls on the eggcup. I worked the pencil fairly dark from the sides of the composition, lightening off steeply towards the centre. The highlights within the eggcup suddenly stand out once the entire area has been shaded in. These form key focal points to the drawing.

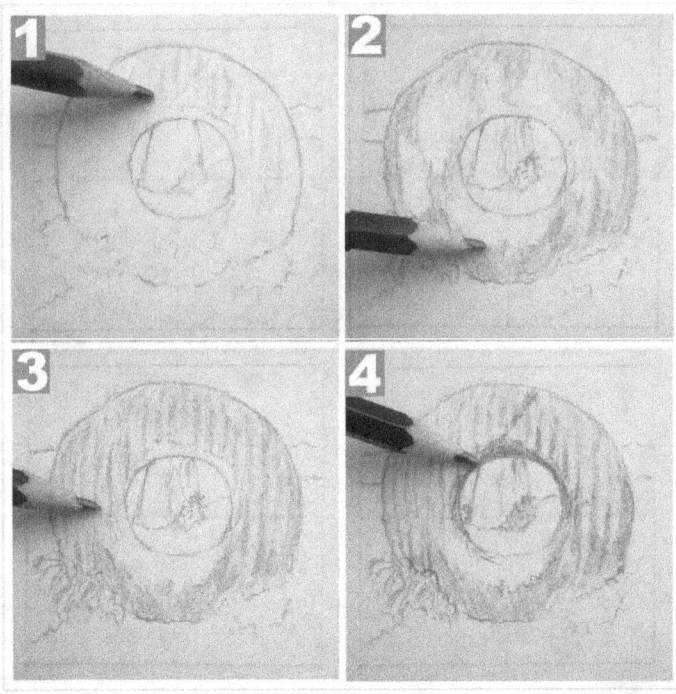

1: The standing stone Men-An-Tol in Penzance has already been drawn out earlier. These enigmatic stones resemble a doughnut and spike stuck into the ground. I began with the striations on the 'doughnut', working downwards. These strokes are expressed unevenly to echo the rough texture of the stone.

2: I moved the pencil to the bottom of the stone, expressing rustic shading at the base where stone meets grass. Concurrent, I expressed rudimentary marks onto the spike-stone in the background.

3: I continued to express the striations on the stone, careful not to create a regimental finish. In places the stripes are broken up or jagged. A little shading has been applied between the stripes to suggest clefts.

4: Once the stone's striations have been expressed, I worked a diagonal slash across the uppermost section of the doughnut. I then reinforced shading on the underside of the stone and within the slash to give a three-dimensional effect.

5: I continued to express heavy shading to the stone's underside and the striation's lower sections. Rudimentary shading was then applied to the landscape glimpsed through the 'doughnut's' hole.

6: Patchy shading was applied to the background and worked into. Notice the parallel ripples in the stratocumulus clouds echo against the striations on the stone, providing interest.

The foreground grass was expressed via controlled scribbles, completing a patchwork of textures that runs throughout the drawing.

7: Via the worn edge of the pencil, I expressed a band of pine trees running across the background. The Men-An-Tol structure now appears to inhabit a setting.

8: Finally, the ripples of the clouds were worked a little darker, as well as select areas of the grass. A sense of distance has now been emphasized.

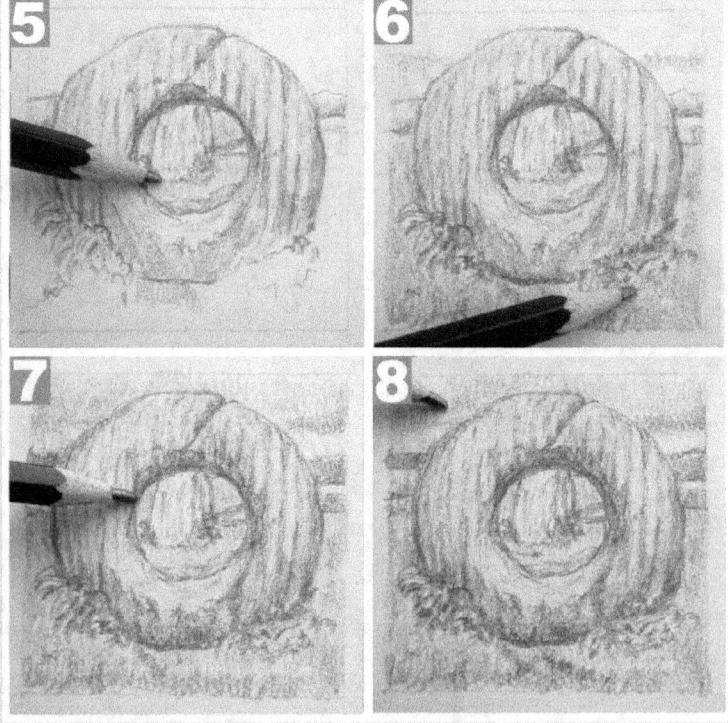

1: The daffodil has been drawn earlier by exercising all four fields of vision. Notice the petals are not quite symmetrical due to the angle. I added a little detail to the petals in order to suggest the folds where light shading will be applied.

2: I worked from the centre of the flowerhead (the stamen) where a shadow resides. Drawing abstract shapes is good practice for seeing an object in its integral parts as opposed to what it is. The shadow resembles nothing in particular but a convoluted blob.

3: The shadows on the petals' outer reaches also have abstract qualities. A deep but not black tone was aimed for here. Notice the foremost shadow slashes the petal almost in half.

4: The petals can be viewed as triangle or diamond shapes with sections cast in shadow. The shadows' outer edges appear to ripple in places.

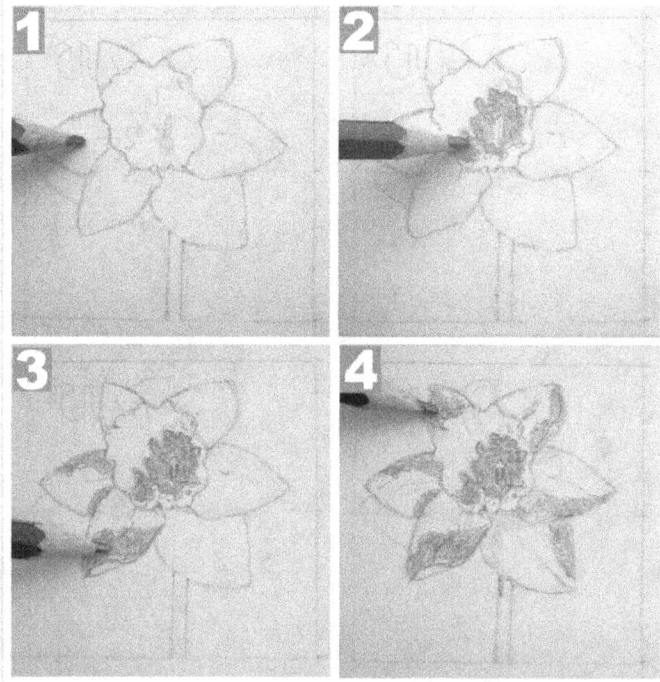

5: With the abstract shadows expressed, I applied light shading onto the sunlit areas of the petals, for this will inform upon the delicate folds. I eased off towards the edges where the sunlight was at its strongest. I then worked vertical shading onto the stalk, lightening off towards the right.

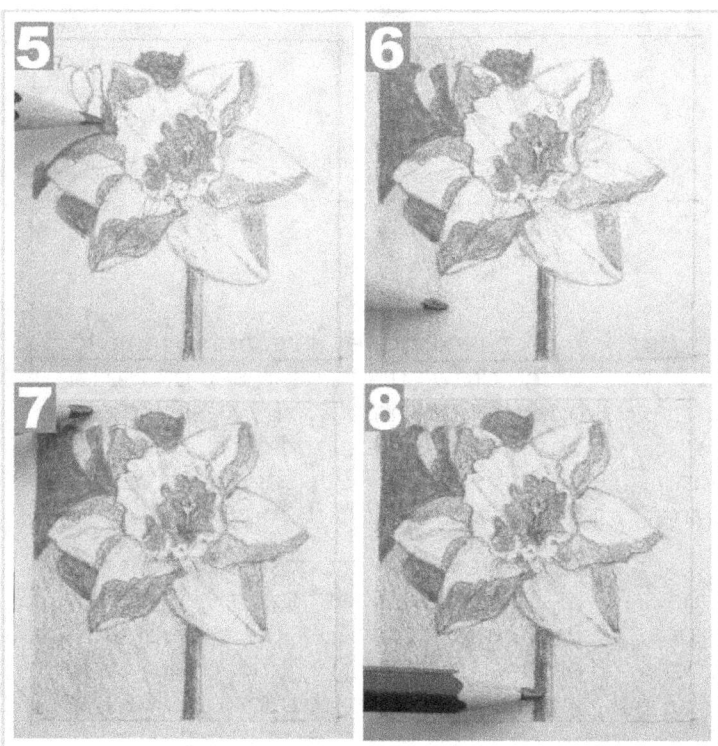

6: The shadow in the background is an important focal point and could easily resemble a meaningless blob if not rendered sensitively. This forms the darkest area of the drawing but was initially sketched in lightly. Notice how the shadow fans out with odd convolutions towards the upper left of the drawing.

7: I worked a little darker on this odd-shaped shadow, careful not to go over the daffodil head. Notice how this shadow brings out the flower head in sharp relief.

8: I applied soft shading to the background in order to reinforce the sense of a light source. I worked this shading slightly darker to the left of the composition. I then added extra punch to the darkest areas of the drawing such as the stem and stamen. A strong sense of light has now been achieved.

Drawing Project 4: Distortions from Glass

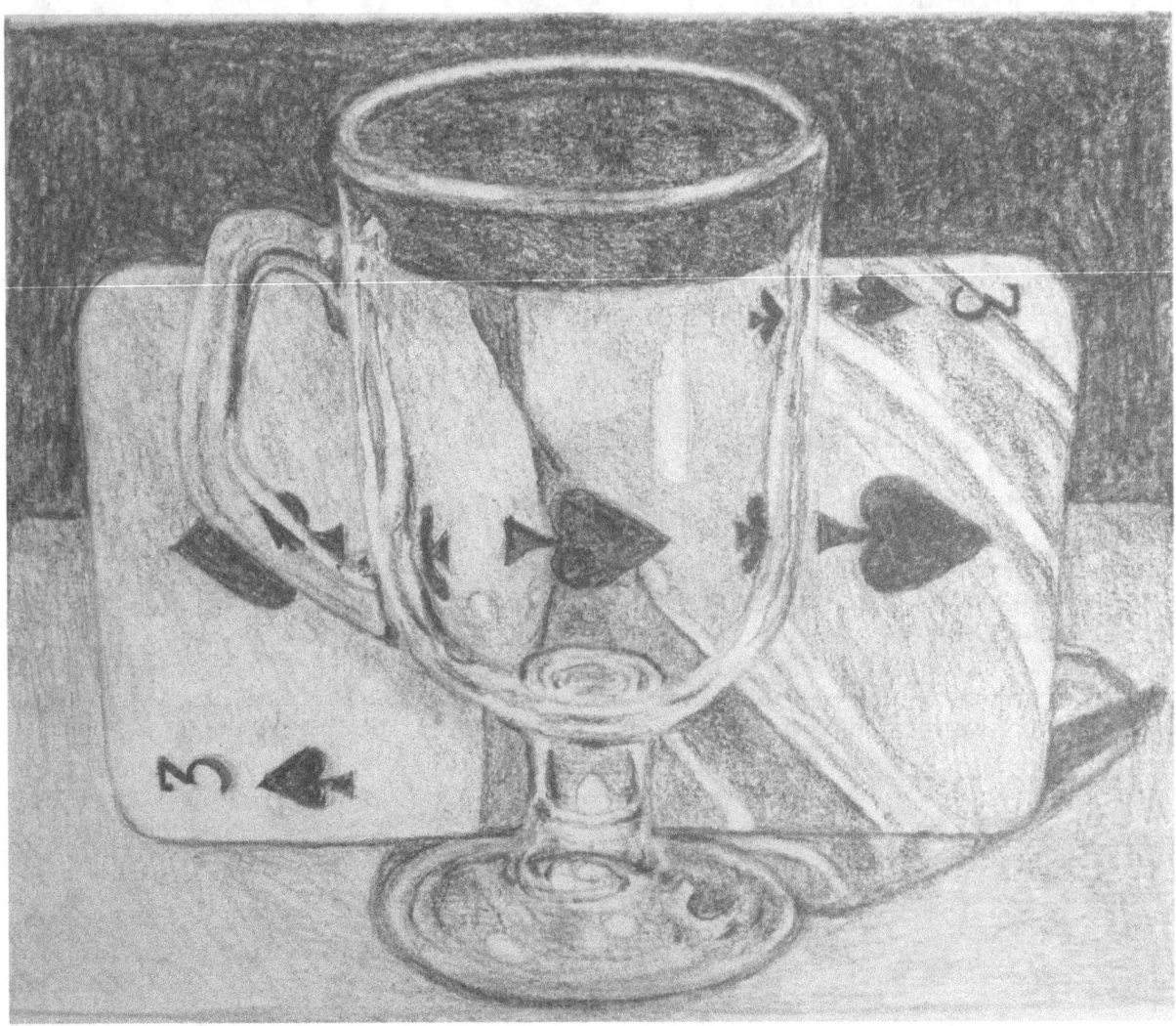

This glass cup poses several challenges. Not only is the cup a symmetrical form, but also possesses shadows, reflections and distortions. The ellipses are perhaps the greatest challenge of all. The preliminary part of this exercise will make the drawing easier.

I have placed a playing card behind the glass in order to explore how distortions in glass affect an image. The three-of-spaces has been selected for the spades' placements in relation to the glass.

The central space provides the main focus of the drawing, while the one on the left has been split into two by the handle. The one on the right falls within bands of sunlight. As can be seen, the spades offer further symmetrical shapes for drawing.

Notice reversed images in the glass as well as odd tonal bands that fall onto the card. These abstract shapes are a great way of practicing drawing without concerns for what each shape 'should' look like.

1: This image comprises a composite of four.

A: shows a 12x15cm rectangle divided into quarters. In **B** I have subdivided the top line further. Two vertical lines were then drawn downwards from these coordinates, converging slightly.

In **C**, I drew a horizontal line 1.5cm from the top and another 1.5cm from the bottom. **D** shows the resultant quadrangle in the centre of the composition. I have darkened it for clarification purposes. This is where the glass will inhabit. As always, the lines have been drawn lightly.

2: Drawing a symmetrical shape is now made easier. Within the quadrangle, I have sketched a simplified goblet shape.

3: Upon the 'cross' formation at the top, I drew the ellipse. As can be seen, the ellipse is a flattened oval shape. An inner ellipse was then drawn to suggest depth. Notice the width of the ellipse appears slightly thinner further from the viewer.

4: I refined the contour of the glass as I worked the pencil downwards, adding elegance to the shape and then I ended this with the rudimentary sketch of the ellipse at the base of the glass.

Again, the cross located at the bottom serves as an aid to drawing an ellipse. Centring an ellipse onto a cross can be a useful method in rendering this tricky shape.

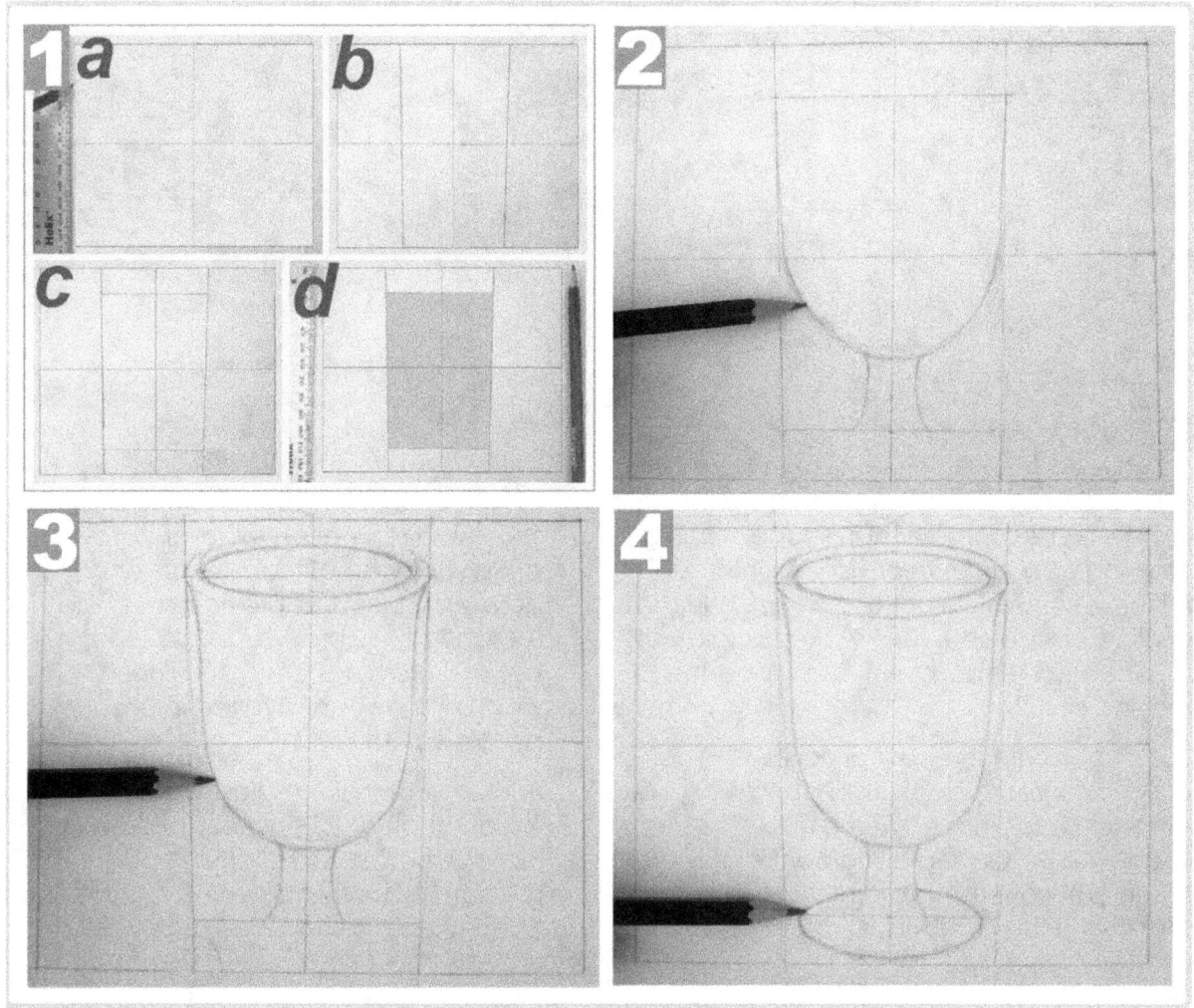

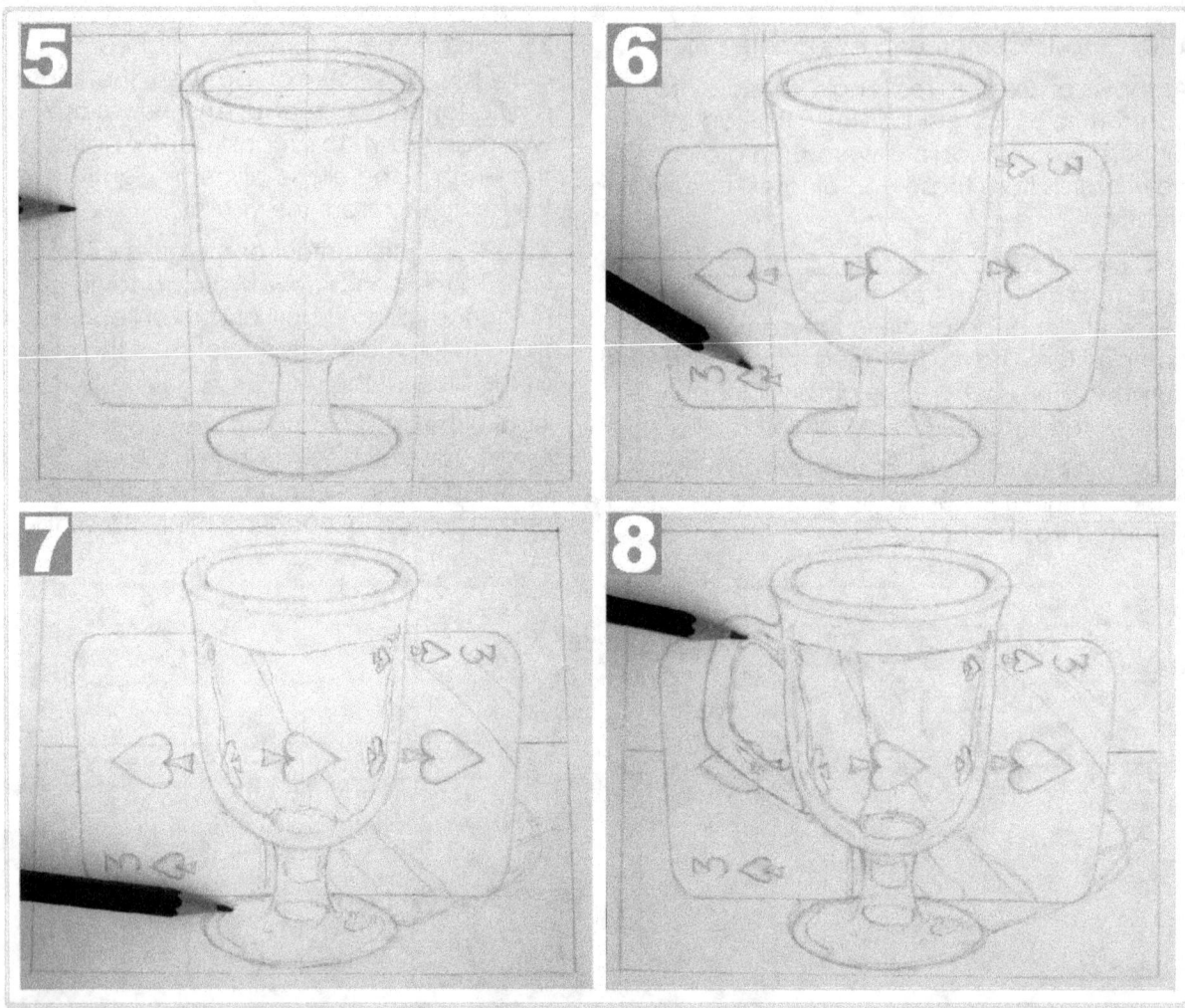

5: Before progressing, I ensured the glass and ellipses were symmetrical in shape. Turning the drawing upside down or viewing it through a mirror will help highlight deviations. Using the gridlines as a guide, I drew a rectangle with rounded edges as shown. This will be the playing card.

6: Just beneath the central horizontal line, I drew out three spades. Each should be equally distanced apart and symmetrical. The central spade will be placed dead centre of the glass. I then drew out the two motifs in the corners along with the numbers.

7: This initial part of the drawing may seem exacting but is excellent drawing practice. Symmetrical objects and perpendicular lines provide a workout for the part of the brain responsible for skewed drawings or sloping lines. Odd shadow shapes and reflections can now be drawn out.

8: The handle of the glass was sketched via an angled 'C' shape. Notice how it slices a motif in half. Drawing outlines in relation to another object is a good way of ensuring accuracy, as seen here.

9: And now for the shading. With the 2B, I lightly shaded the odd triangle shapes that cut across the glass, working darker. Notice how the shapes appear to stretch out within the oblique light. Bands of shadow can also be seen on the card.

10: Lighter shading was applied onto the rest of the card. Be careful not to shade over reflections in the glass nor the bands of light that cut across the card. I moved the pencil downwards, using light, circular strokes. Care is needed at the base of the glass where semicircles and crescents twirl.

11: I continued to work soft shading over the card, keeping the pressure even on the pencil. I then worked a mid-tone on select areas around the stem of the glass. Take extra care here as there are odd sunlit shapes with sharp edges. Getting this part right is important, as it provides the setup for the spades.

12: I applied sharp edges to the highlights to make them stand out. I then worked on the spades, ensuring edges are crisp and the shading is dark. Notice how the spades are distorted by the glass and how some appear in reverse.

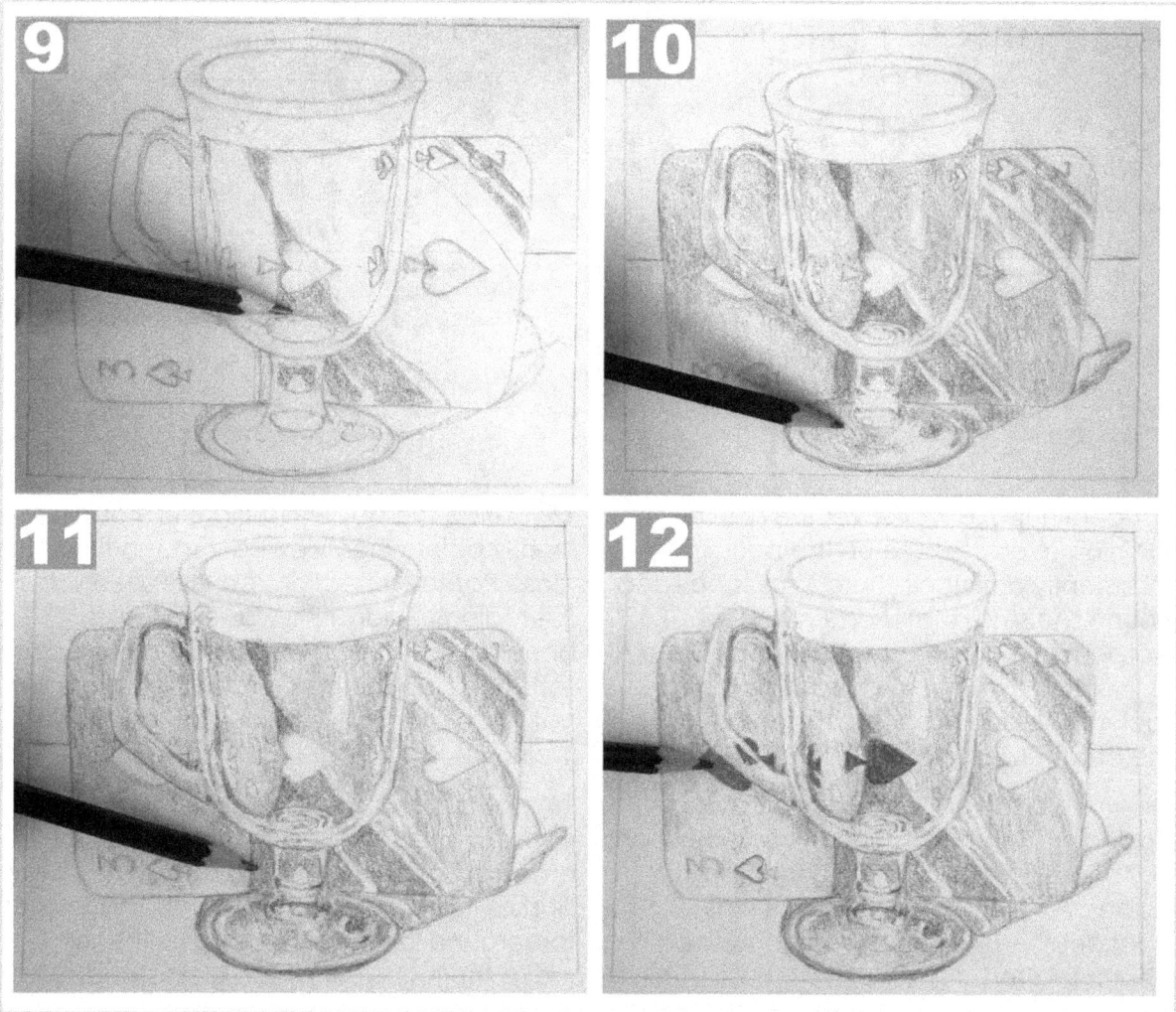

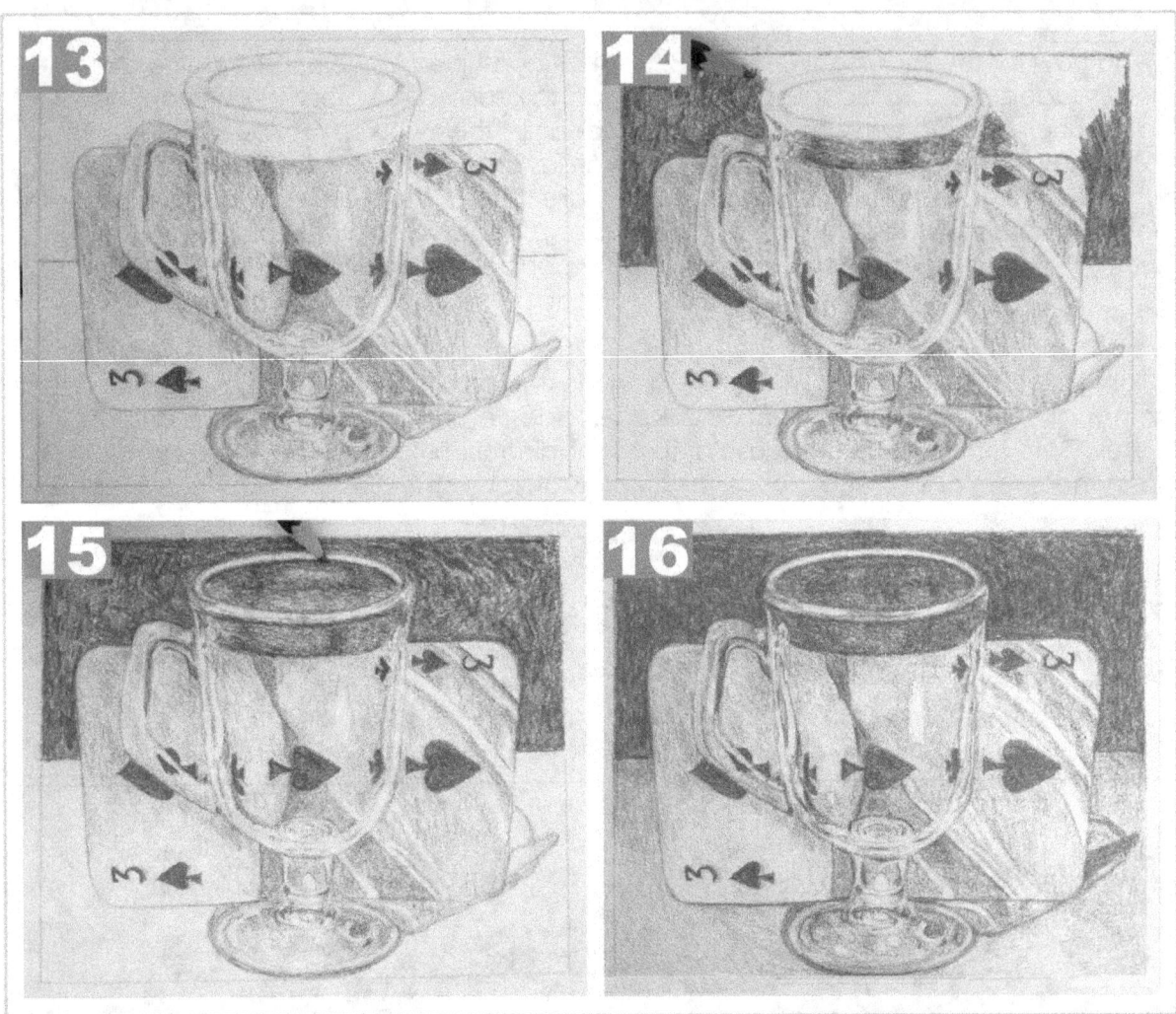

13: I continued to work over the spades, retaining even pressure on the pencil for a consistently dark tone. Extra care is needed around the small motifs and numbers. Sharpening the pencil may be necessary. At this point, it might be a good idea to stand back to see how the tonal shapes key into one another.

14: With the soft edge of the pencil, I shaded in the background. As can be seen the tone is dark, but not as dark as the spades. A tightly-woven scribble was practiced here, where marks echo the subject matter.

15: Notice the upper background appears slightly paler when viewed through the glass. Patchy reflections can be seen within this region. A dark ring was expressed beneath the lip of the ellipse and the edges softened out. This part is tricky, so take care not to go over the highlights of the ellipse itself.

16: Notice tonal variations around the ellipse. I lightly shaded sections, leaving others untouched. This will suggest the shiny part of the ellipse. Finally, I lightly shaded the foreground in roughly one tone. This will make the highlights of the glass stand out.

Drawing Project 5: Stacked Chairs

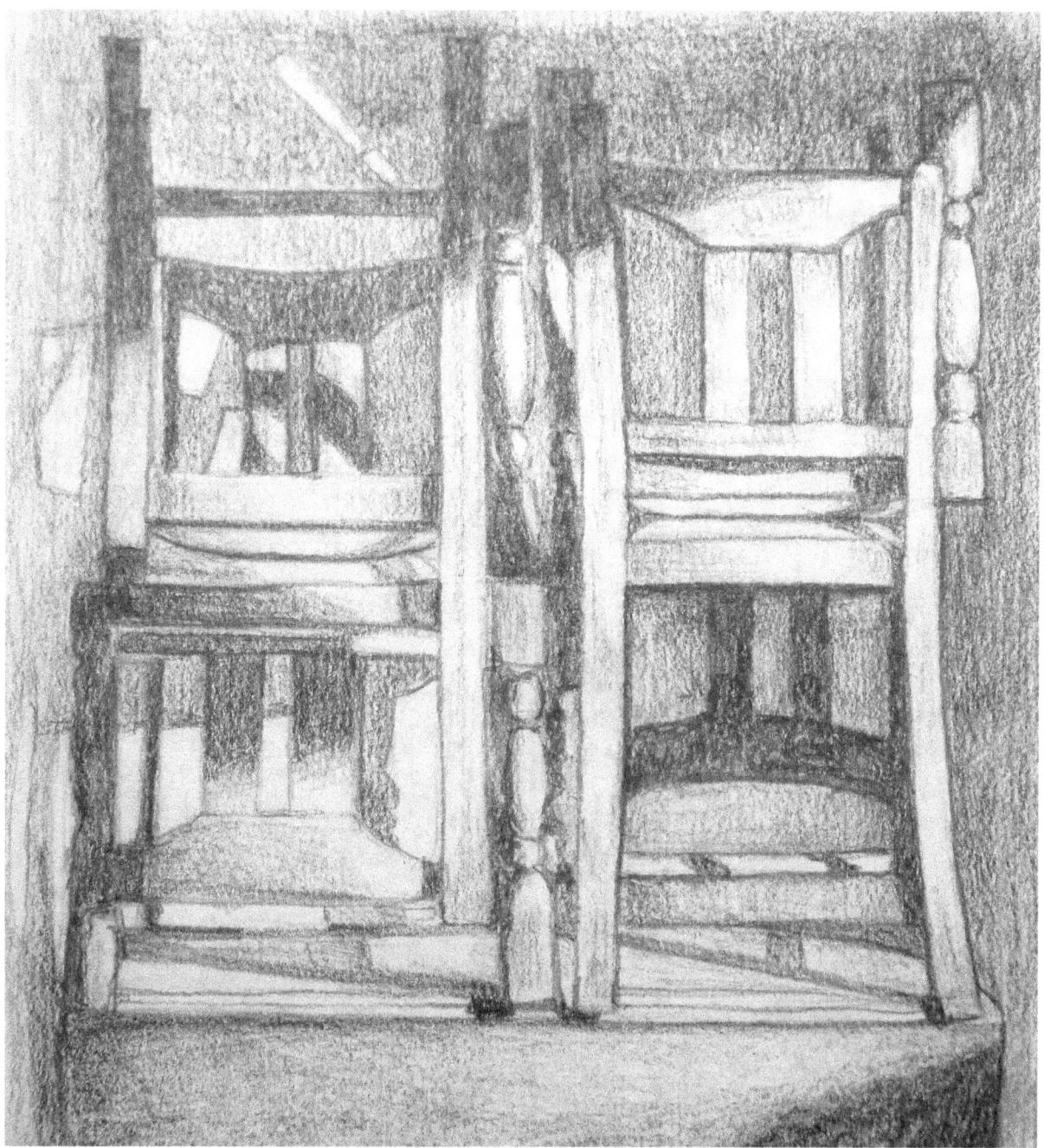

The previous drawing project looks at symmetry. This one goes one step further in that the composition can be seen as having further symmetry. These stacked chairs are not strictly symmetrical but can be drawn in four sections.

Shapes echo one another but exhibit crucial differences. Notice how the composition can be anchored onto a central cross.

Again, this project exercises all four fields of vision.

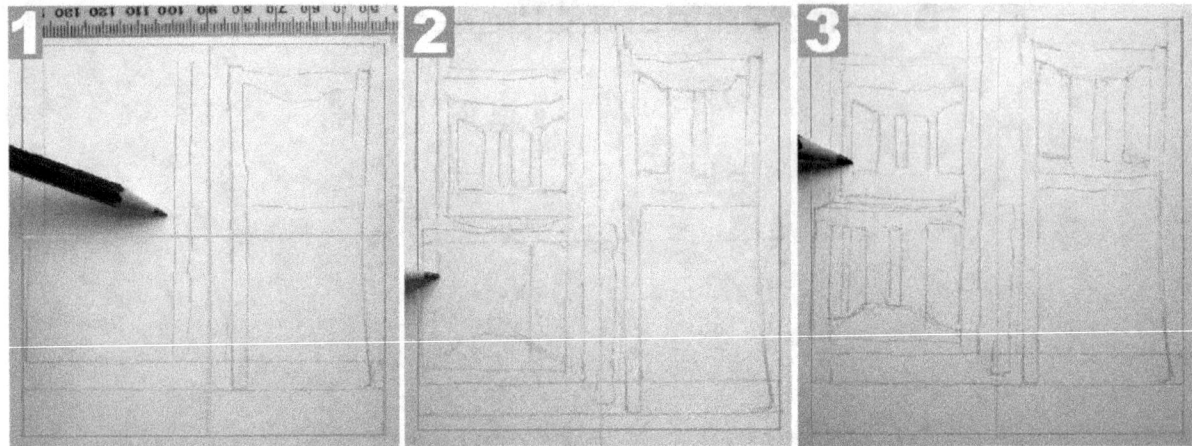

The image below can be used as a drawing aid. It shows how the composition can be divided into four sections. Notice odd rectangles, rhombi and oblongs. This is due to the light hitting the chairs from an oblique angle. When viewed in isolation, these shapes make little sense until viewed as a whole.

I drew a rectangle measuring 12cm wide and 14cm long. I then drew a cross, dividing the image into quarters. Keep the lines soft at this stage. The gridlines can be used as a means of guarding against sloping lines and deviations. Notice how each line relates to the cross (and frame) regarding angle and contour.

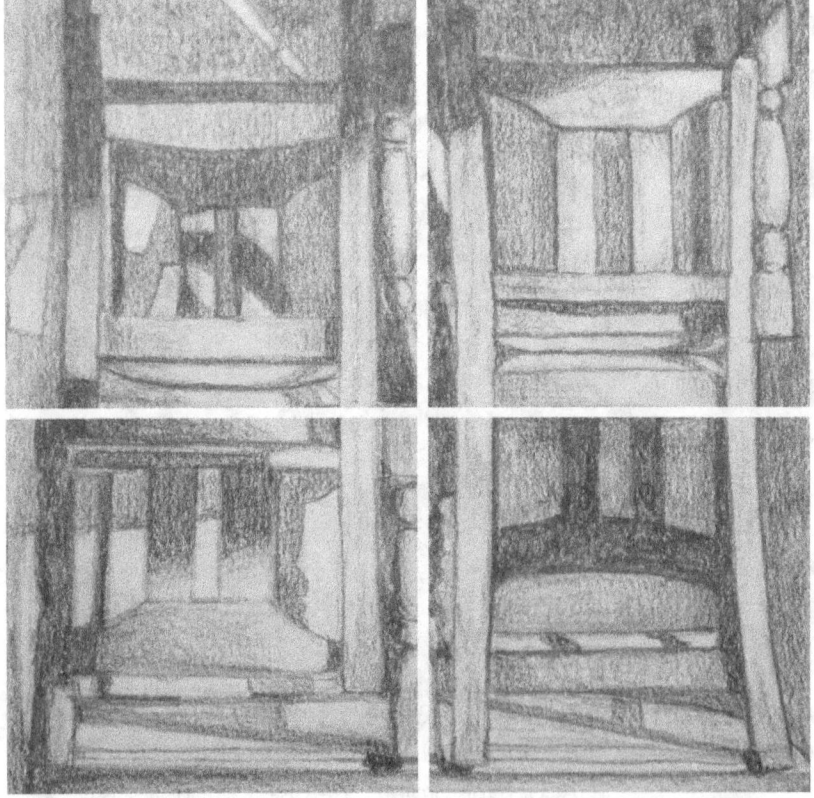

1: Although the chairs feature perpendicular lines, I drew them freehand. These lines need not be ruler-straight. Wobbles and little imperfections add charm to a drawing; a draughtsman's finish is not the aim.

I began with the largest shapes. I worked the pencil in vertical strokes on either side of the 'cross' in order to express the sides of the chairs.

2: I then expressed the chair seats via a series of horizontal lines. Again, Notice how these lines relate to the central cross.

3: Once the quadrangles have been expressed and are perpendicular-true, the chair backs can be worked into.

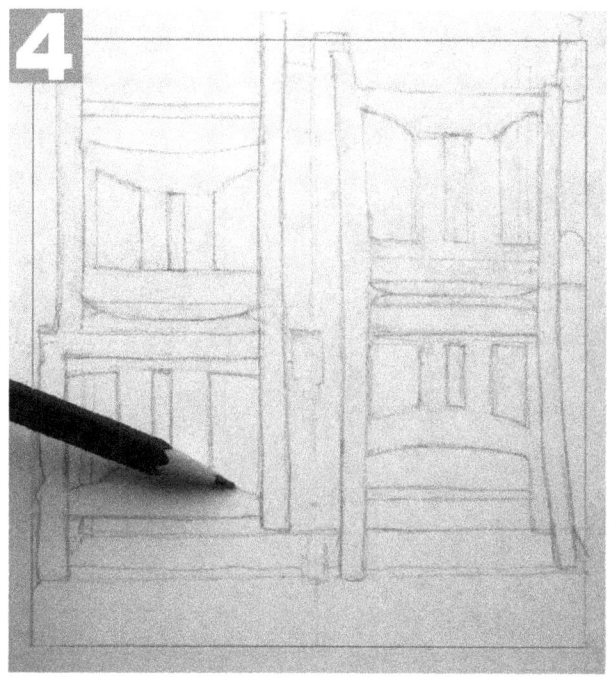
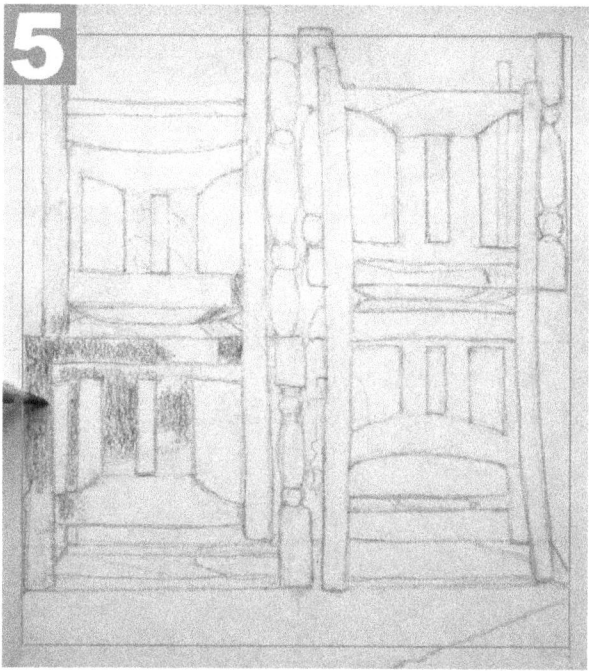

4: Notice negative spaces between the structures of the chairs, such as the series of three rhomboids on each chair back and rectangles at the bases. Lines are kept to true due to the gridlines drawn earlier.

5: Once the shapes fit together like a jigsaw, I worked a little darker, making further modifications along the way. Outlines to shadows were sketched in before I rubbed out unwanted lines, including the central cross.

With the 2B pencil, I began shading the shadows on the chairs. The oblique sunlight hitting the slats creates odd slanted shapes, further informing upon the chairs' form.

I worked the pencil in soft strokes, careful not to venture onto the background. Notice how some edges are softer than others.

6: The shadows fall upon the chairs in stripy formations. Diamond, triangular and rectangular shapes can be seen here. I worked further downwards, expressing blocks of shadow upon the lower legs.

I kept the pencil moving, using the worn nib for smooth effects.

Exercise 5: the Framing of Negative Space can be practiced here, as negative space can be anchored into place within a frame via linking lines. The lines are mostly straight as opposed to mostly curved.

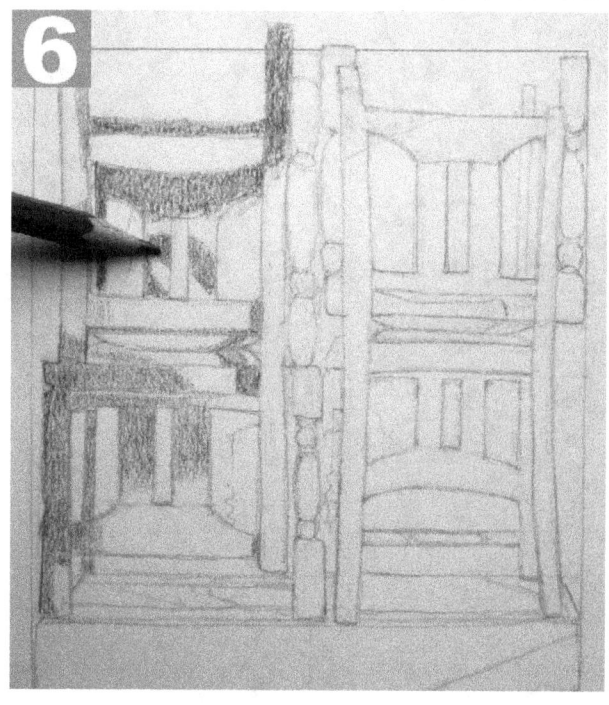

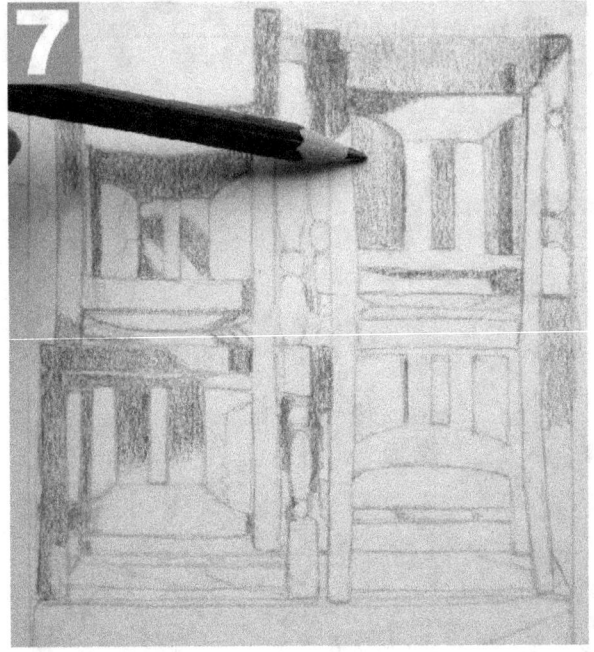
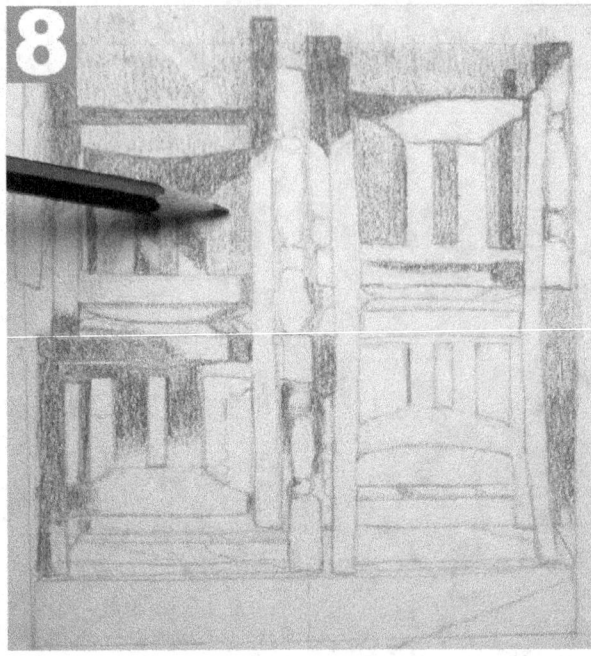

7: In order to see how sunlight and shadow key in together, I softly shaded in blocks of background to the chairs. Be careful not to go too dark or this will clash with the shadows expressed earlier.

As can be seen, as soon as the background is shaded in, the sunlit areas stand out. This enabled me to judge the accuracy of these shapes and to make necessary modifications. An eraser can be used.

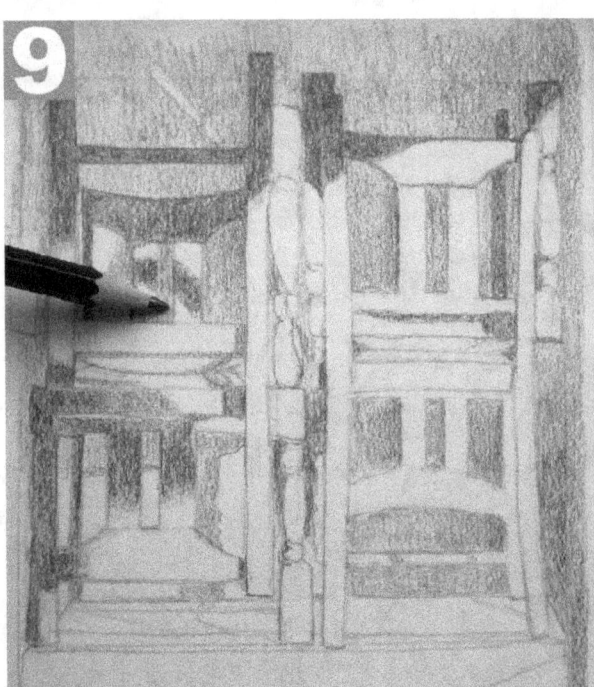

8: The background is not simply flat, but fluctuates in tone. I therefore applied additional shading to select areas. Notice a splinter of sunlight hitting the upper left wall and a wobbly shadow from a chair leg hitting the lower left. These odd shapes provide interesting focal points to the drawing. Edges are kept crisp here.

9: The remainder of the background was worked over, aiming for a fairly even tone. Exercise 1 'Even Shading within a Square' is worth revisiting. In places, a second, softer layer of shading might be necessary if marks draw the eye.

Additional shading is required where the tone varies slightly, for instance on the upper and lower right of the image. With the background shading complete, I resumed with the rest of the chairs.

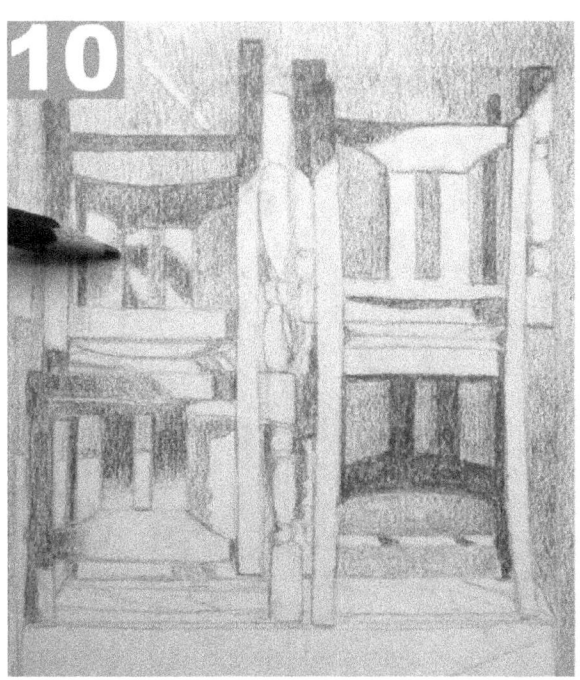
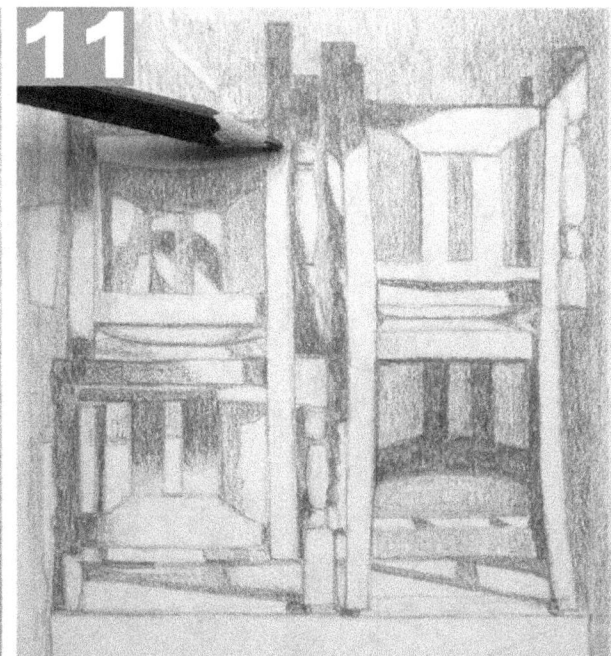
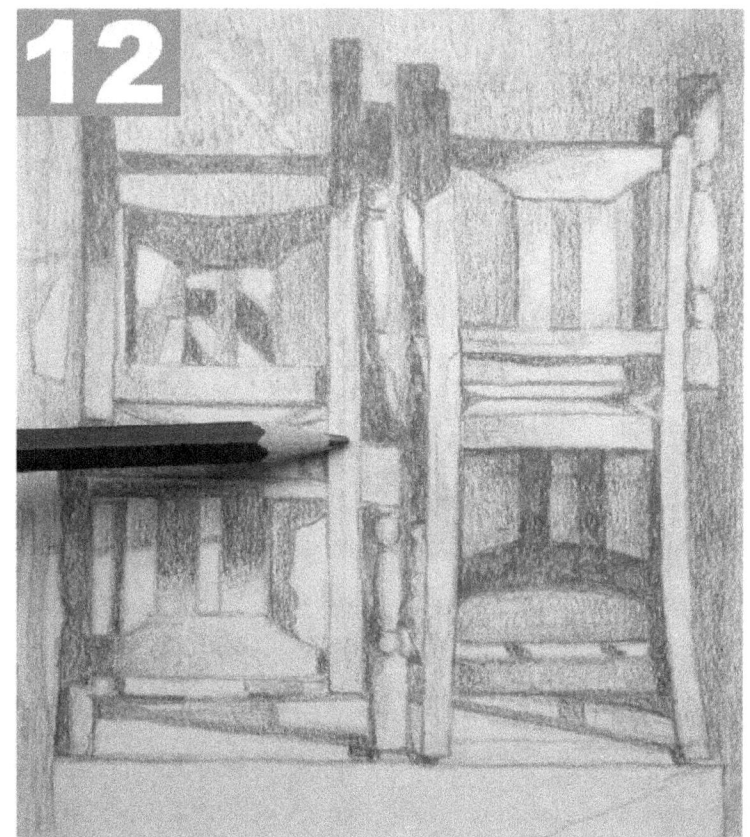

10: A shaded background enables me to judge more accurately how sunlight and shadow key in together. I applied an even block of dark to the upside-down chair on the lower right quadrant. This will provide the darkest area of the drawing and a benchmark from which to judge the other tones.

11: The centre of the drawing comprises the chair legs. Nodules and grooves can be seen here. I expressed shadows that fall diagonally across these legs. I also expressed odd capital 'A' shaped shadows on the table top on which the chairs rest.

12: Even sunlit areas will exhibit variables in tone. Here, I applied light shading to inform upon how the chairs bow against the light. I then applied a diagonal shadow slicing across the leaf table. The edges were softened out and shading brought in from the left.

Exercise 7: Jigsaw Pieces

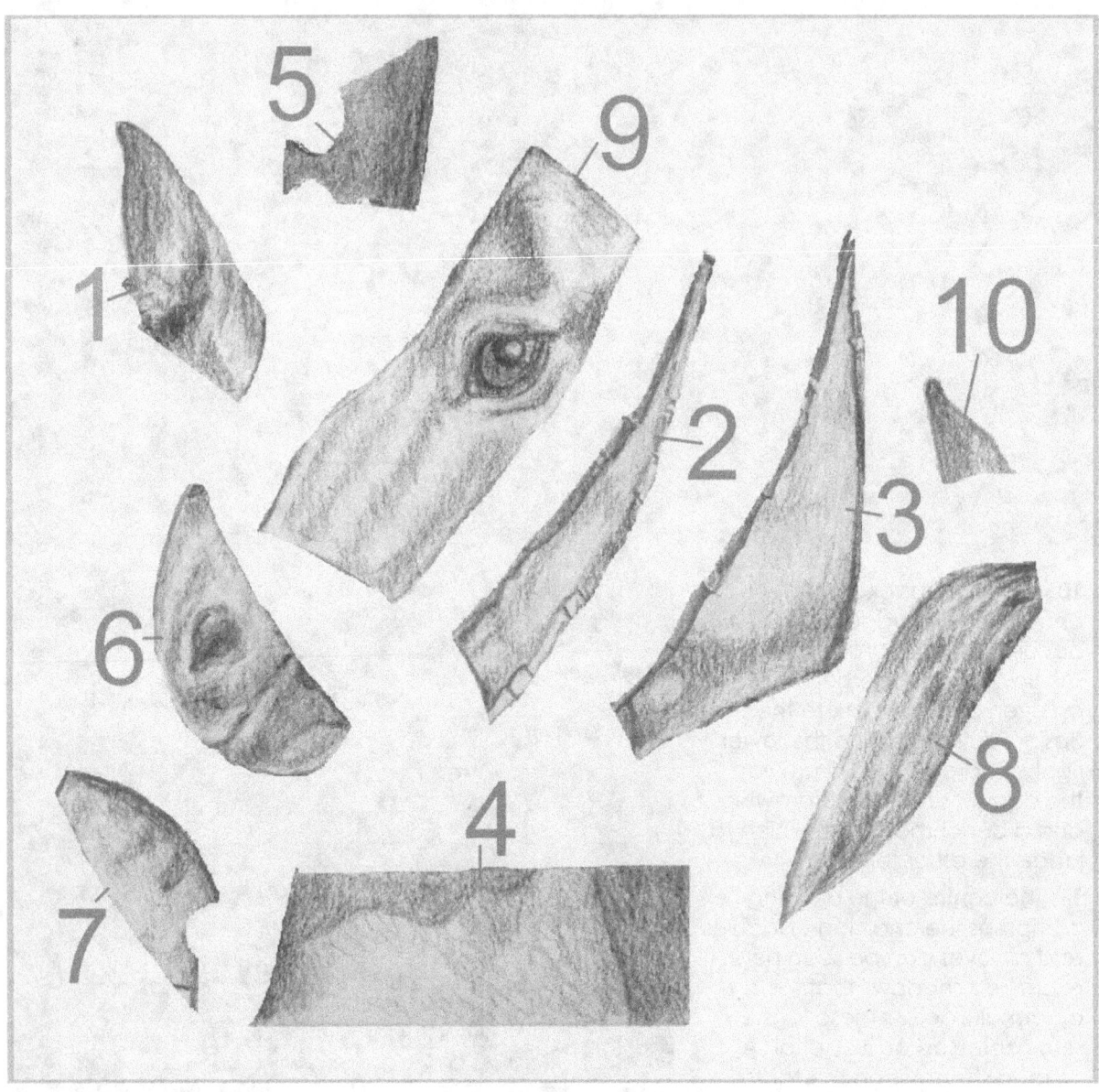

This exercise forms the groundwork for the following drawing project: Horse Head.

I chose this image for the reins conveniently slice up the horse's face into pieces, rather like a jigsaw. Viewing a drawing as pieces rather than as a whole can help make the drawing more manageable.

The pieces shown here have been mixed up. Notice how odd these pieces appear in isolation. Some are almost unrecognizable. Odd shadows and features can be found within each shape.

Have a go at drawing one or more of these pieces. Drawing abstract shapes is a great way of switching off the bossy part of the brain that tells us what an object 'should' look like. It will also make the following drawing project feel more achievable.

The image shows how the pieces fit together. When drawing the horse, take note of the shading enclosed within each shape. For instance, shape 3 (forming part of the horse's cheek) comprises mid-tone overlaid with a shadow band running across. A pale dot punctuates the left corner.

Shape 1 resembles a flattened cone where a crescent shadow nestles. The tone darkens towards the tip.

Notice also the position of key features within a shape.

In shape 9 for instance, the eye falls just above the halfway point of the angled rectangle. Notice parallel folds running upwards and how they curve around the eye.

In shape 6, the mouth's seam slices across the crescent roughly two-thirds down. The nostril is positioned almost dead centre of the remaining shape.

This is the key to accurate drawing: forgetting what the object is supposed to be, but seeing it as abstract lines, shapes and features.

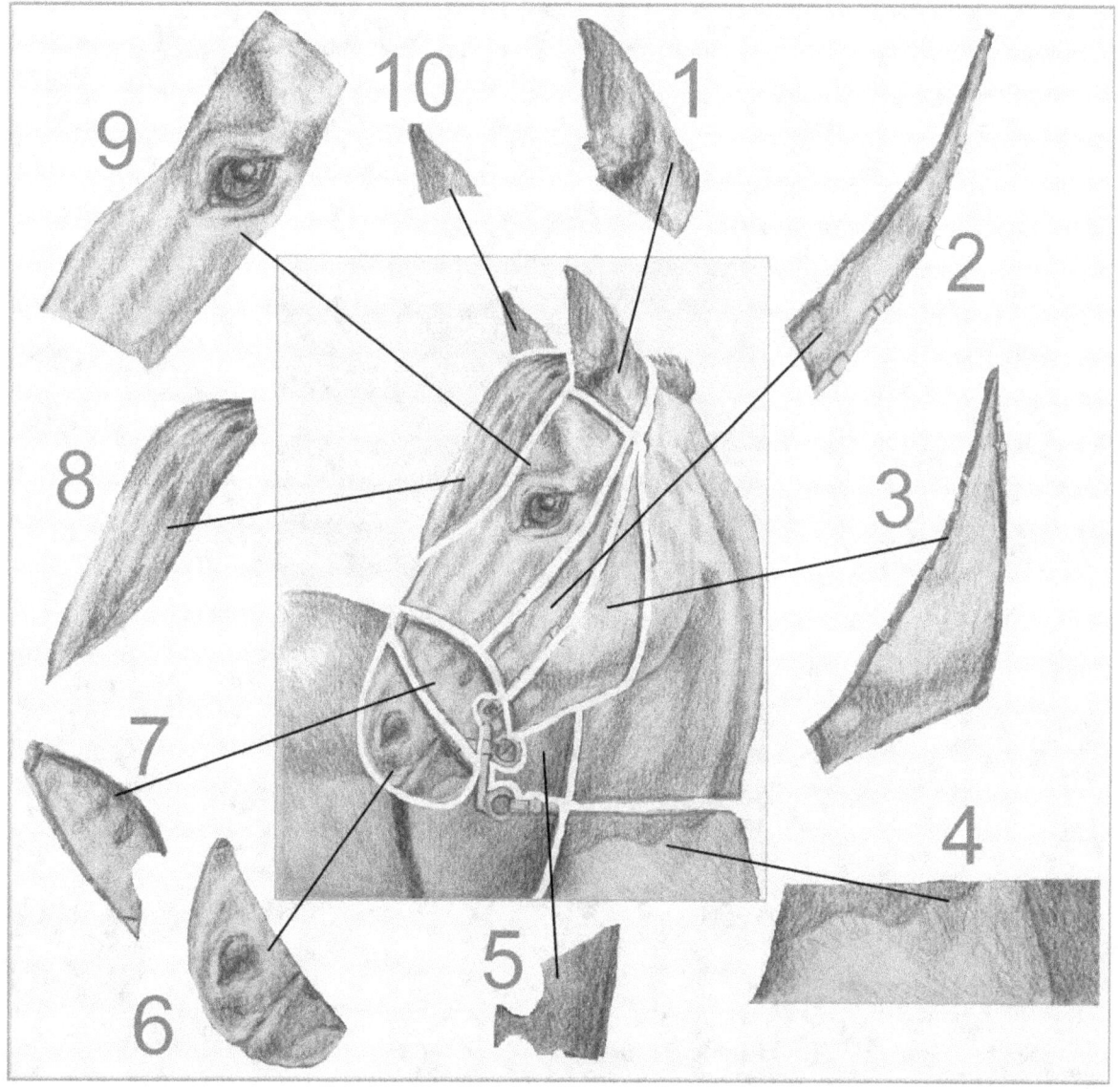

Drawing Project 6: Horse Head

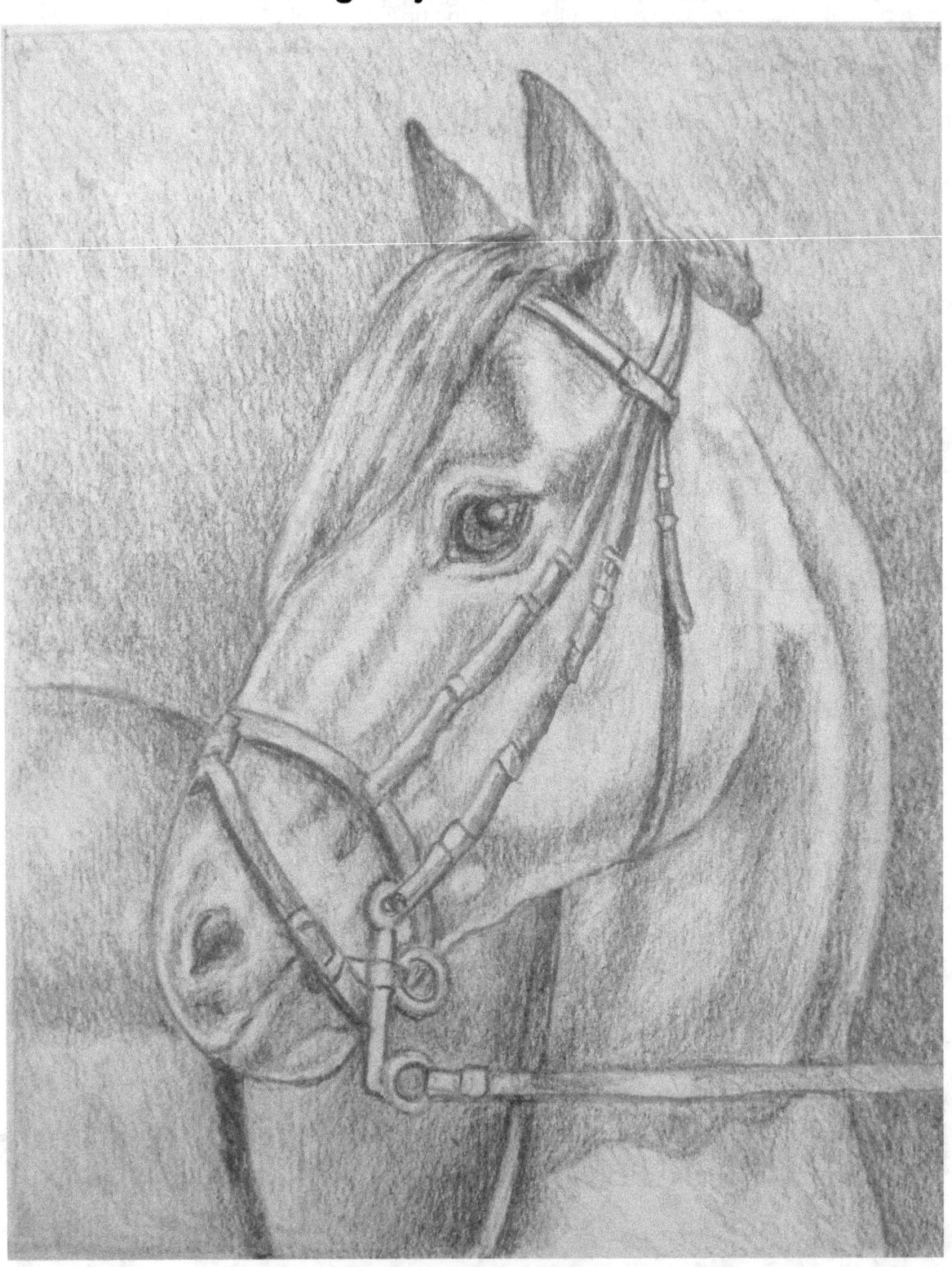

Drawing a horse's head may seem daunting at first, until practicing the previous exercise. However, the larger shapes have to be accurately drawn in before the smaller pieces can fit within them. This means getting the proportions right from the beginning.

1: I drew a rectangle 12x15cm and divided it into quarters. The lines have been emphasized here for visual purposes but are in fact quite faint. Notice the horse's head resembles an elongated triangle with a rounded end. It fits roughly central over the cross.

Both the eye and right ear fall upon the central vertical line. The horse's mane dips towards the horizontal line. Recording such observations will contribute towards an accurate drawing where detail can be worked into.

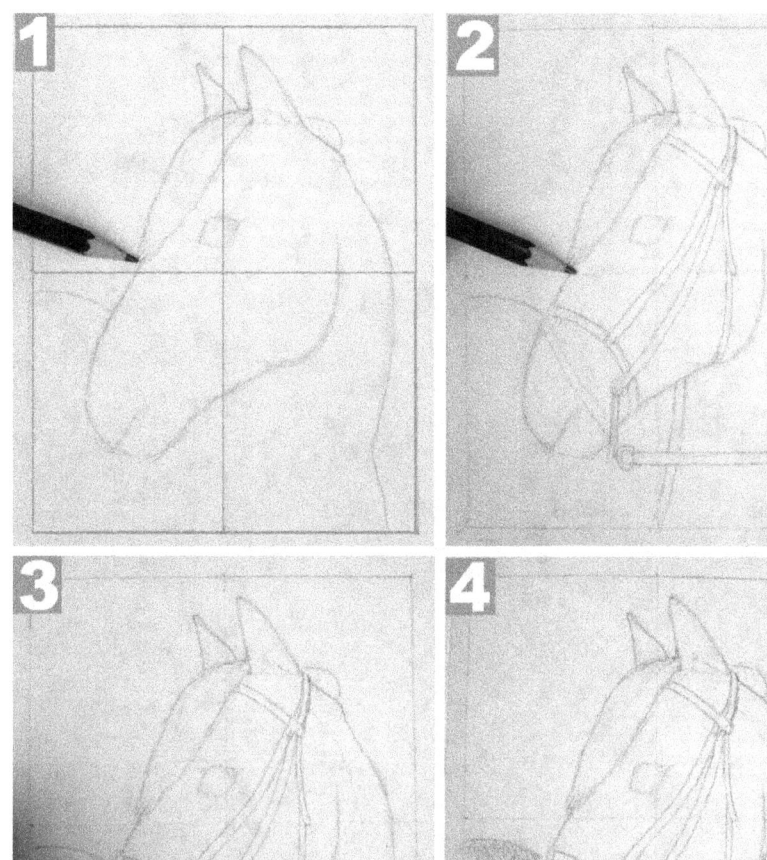

2: Working faintly at first, I drew in the reins. Notice how they slice up the face into jigsaw pieces as already seen. The eye is now enclosed within the slanted rectangular shape and the lower reins slice across the profile, creating odd curves and crescents. Once assured of the lines' accuracy, I drew them a little darker to make the horse more perceivable.

3: I began shading beneath the chin with the 2B pencil. Notice how the lower reins cross over one another, creating right angles. The darkest shadow nestles here. I shaded out slightly from the right angle, working outwards where ridges on the neck can be seen.

4: Shapes 4 and 5 beneath the horse's chin possess dark ridges. Shadow bands run from the corner of the horse's jaw to the neck. The horse's flank and rump exhibits tonal variations. A block of one tone will make the horse appear two-dimensional. This is why subtle shading is essential for describing form. The nature of light falling upon the horse is then described.

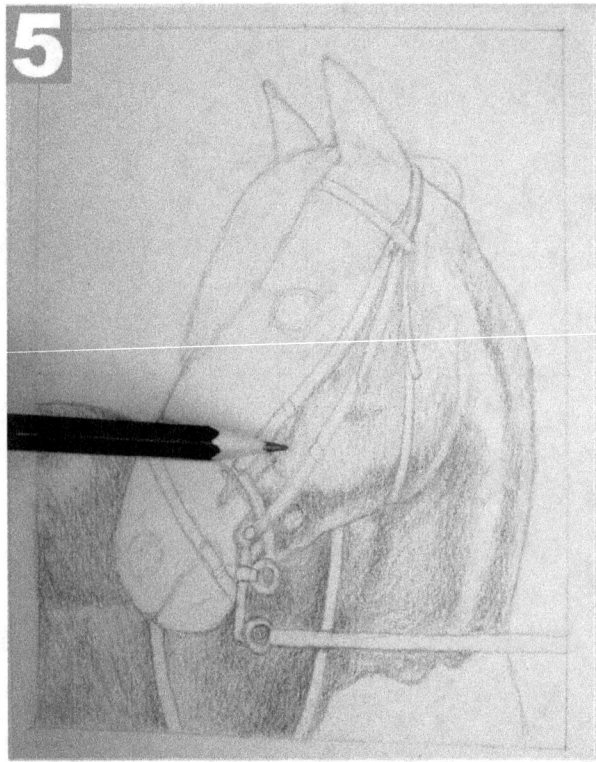
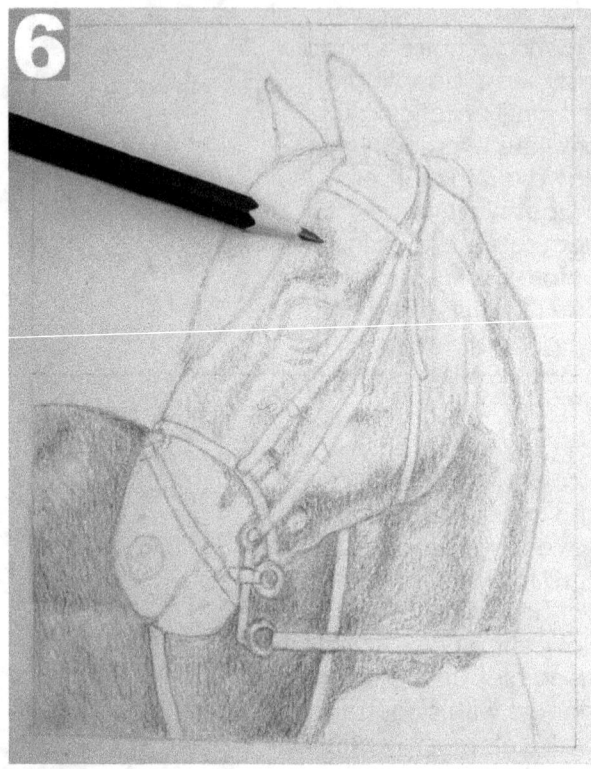
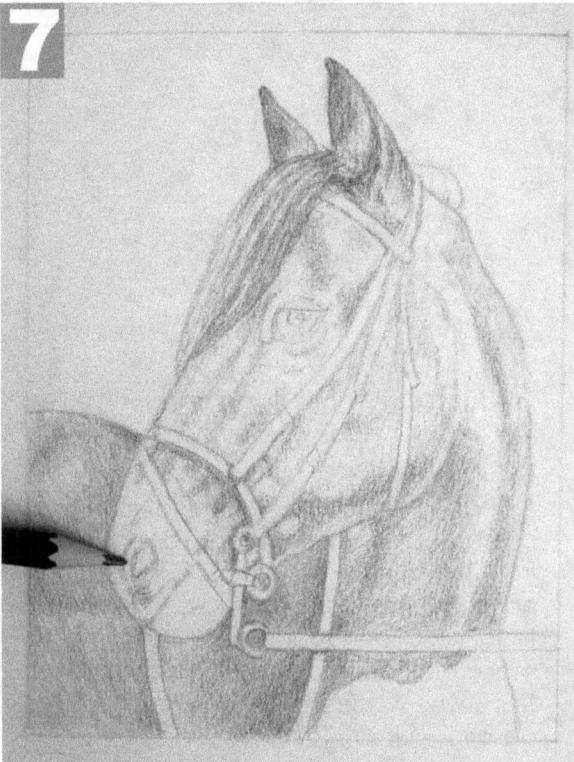

5: Ridges and troughs were expressed upon the horse's neck, curving upwards towards the ears. Troughs were darkened further to create tonal balance with the rest of the horse.

Bear in mind the jigsaw shapes explored in exercise 7. These correspond to shapes 2 and 3. Together these suggest the horse's cheek. Notice soft folds within these shapes that inform upon the horse's facial muscles and veins. A notch of highlight can be seen on the lower jaw and a faint ridge can be seen running across.

6: Shape 9 is now being expressed. Notice three ridges running parallel with the reins towards the eye. I expressed two odd triangle shapes upon the brow bone. These meet at a highlight. Faint crescents can be seen around the eye. This prevents the illusion of an eye being 'stuck' on.

7: Shapes 1, 10 and 8 represented by the ears and the mane required definite streaks from the pencil as seen from the previous exercise. This suggests the nature of the fur.

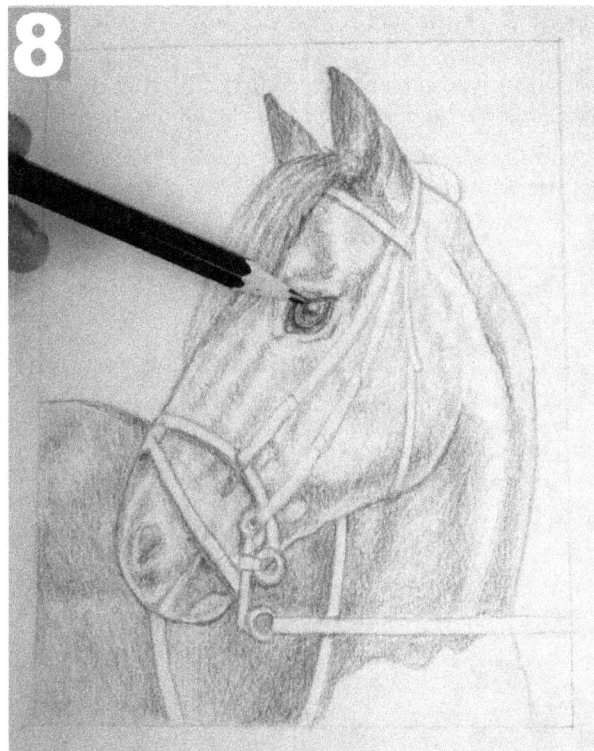
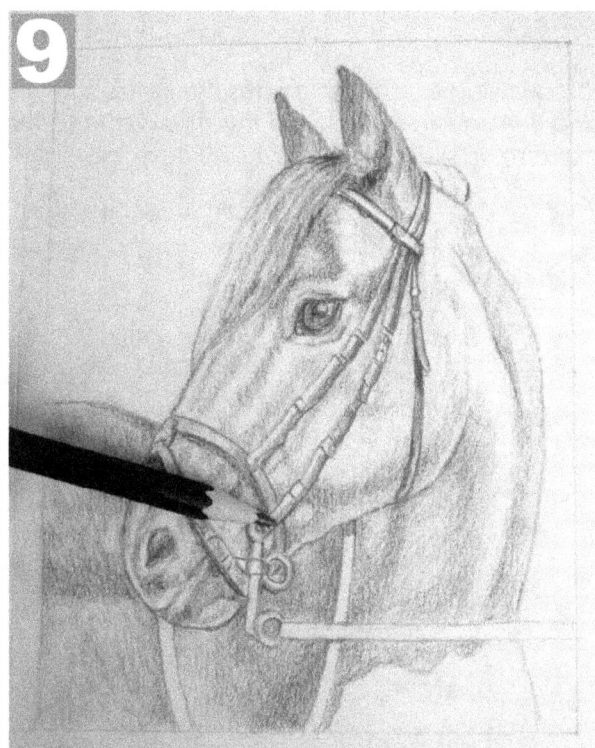
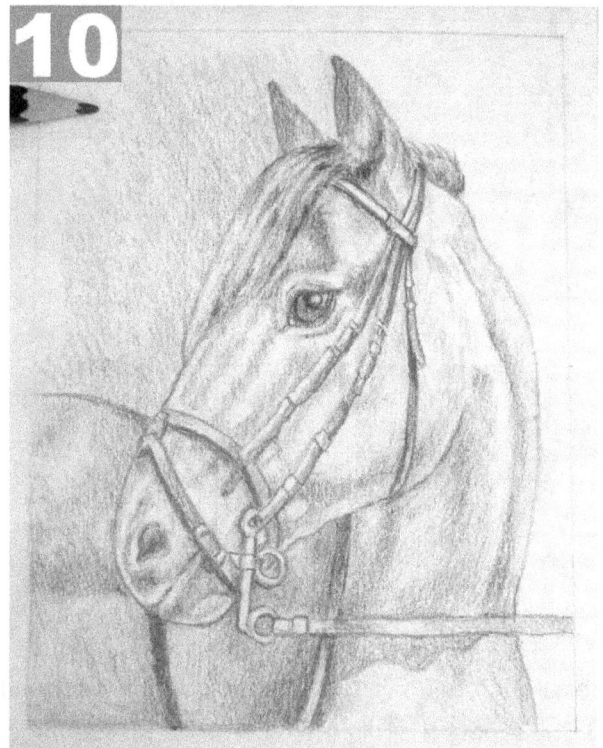

8: I began shading within the snout represented by area 6. The intricate areas of the skin folding into the nostril and the ridges around the mouth seem achievable after exercise 7.

The eye was illustrated with heavy marks around the rims and a dot of highlight just beneath the eyelid. The pupil forms the darkest part of the drawing, fading slightly outwards into the iris.

9: The buckles required heavy lines from a sharpened pencil. Shadows can be seen on the lower sides where they fade out to pale rims. This gives the impression of thick leather straps. Buckles and eyelets were expressed via rectangles and hoops. Deliberation with detail is worth the effort here.

10: Finally, I shaded in the background. This always brings out the highlights of the subject matter. Notice the sheen across the brow-bone, cheek and snout. As can be seen from the final picture, I worked a little darker further down to reinforce the impression of an overhead light source.

Exercise 8: Abstract Shapes

This drawing exercise provides the setup for the following two drawing projects: 7: Daisy Heads and 8: Auguste Rodin's *the Kiss*. This is due to the organic swirly nature of the drawings. This exercise, in six stages, progresses from the simple to the more advanced.

Keen observation is required on several levels. This is because all relate to the five principles of drawing, explained in the introduction. These are outlines, spaces, relationships tonality and the whole. Of course, seeing is fundamental.

Notice the odd shapes presented and how one relates to the other regarding size, shape and position. Bear in mind the weight of marks as well as tone. Each square measures 6cm.

1: This first square is in two parts. Notice the shape on the right resembles the silhouette of an armchair. The dark area is quite solid; the pale area is scratchy in nature.

2: Here the square can be seen as four parts. The adjacent shapes, resembling birds' heads appear to fan out from a central point. They are not quite symmetrical. Again, the tone is solid here. The bottom left region shifts abruptly in tone towards the centre. The upper right exhibits tonal fluctuations, leaving two shapes untouched by the pencil.

3: This square is a little more complex. Notice the dark splotch on the left that resembles nothing in particular. This is the essence of drawing: seeing abstract shapes without interpretation. A line meanders across the centre of the square, where shaded areas can be affixed.

The squares on this page increase in challenge in that the shapes appear to float in space. Few lines exist that can be used for linking to (as seen on the previous page).

Odd marks and intricate shapes can be found. These require care due to their nonfigurative nature which can trick the eye. Retaining an overall view can help.

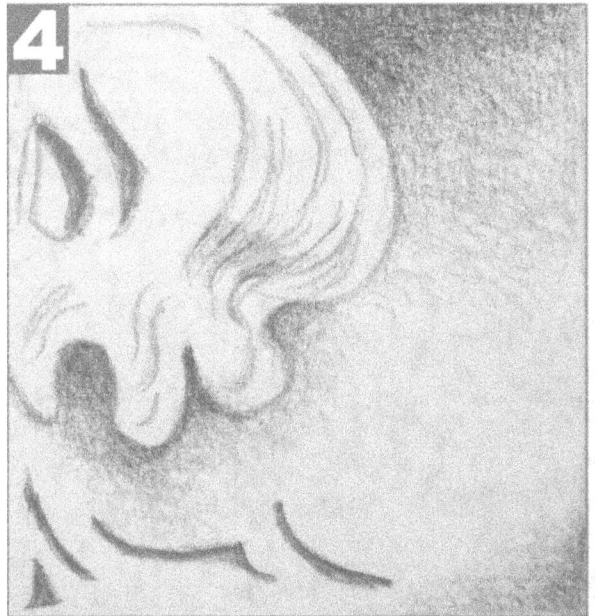

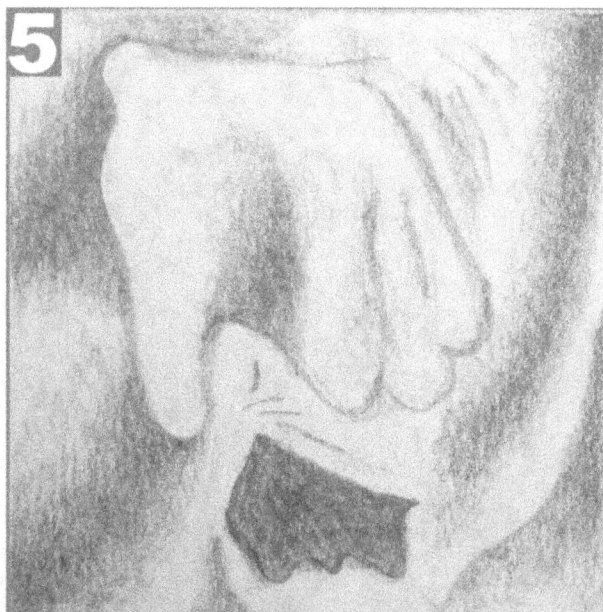

4: A swirly shape resembling a profile appears to bloom out from the upper left corner of the square. Notice an 'eye', brow and pleated whorls within. Four splinters appear to scatter on the lower left. Take note of the shading in the open space.

5: A shape that resembles a hand appears to float almost in the centre of the square. A 'rent' in space is flanked by bands of shadow, each running into upper regions of the square.

6: This final square contains many elements. Two swirly shapes occupy centre-stage; one is dark; the other light. A third shape on the bottom left shifts between the two. In the background, lines of various weights come together to form a braid. The background appears to fluctuate in tone.

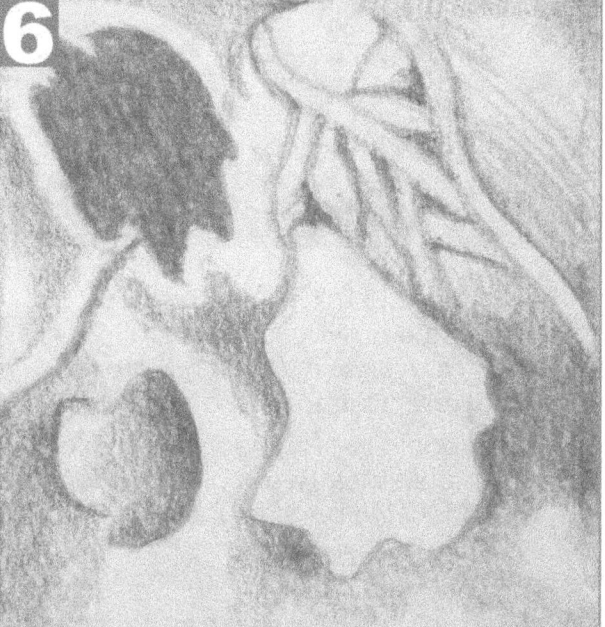

Drawing abstract shapes that resemble nothing in particular is good practice for developing visual awareness. It also provides the setup for the following two drawing projects: Daisy Heads and Auguste Rodin's sculpture, *The Kiss*.

Drawing Project 7: Daisy Heads

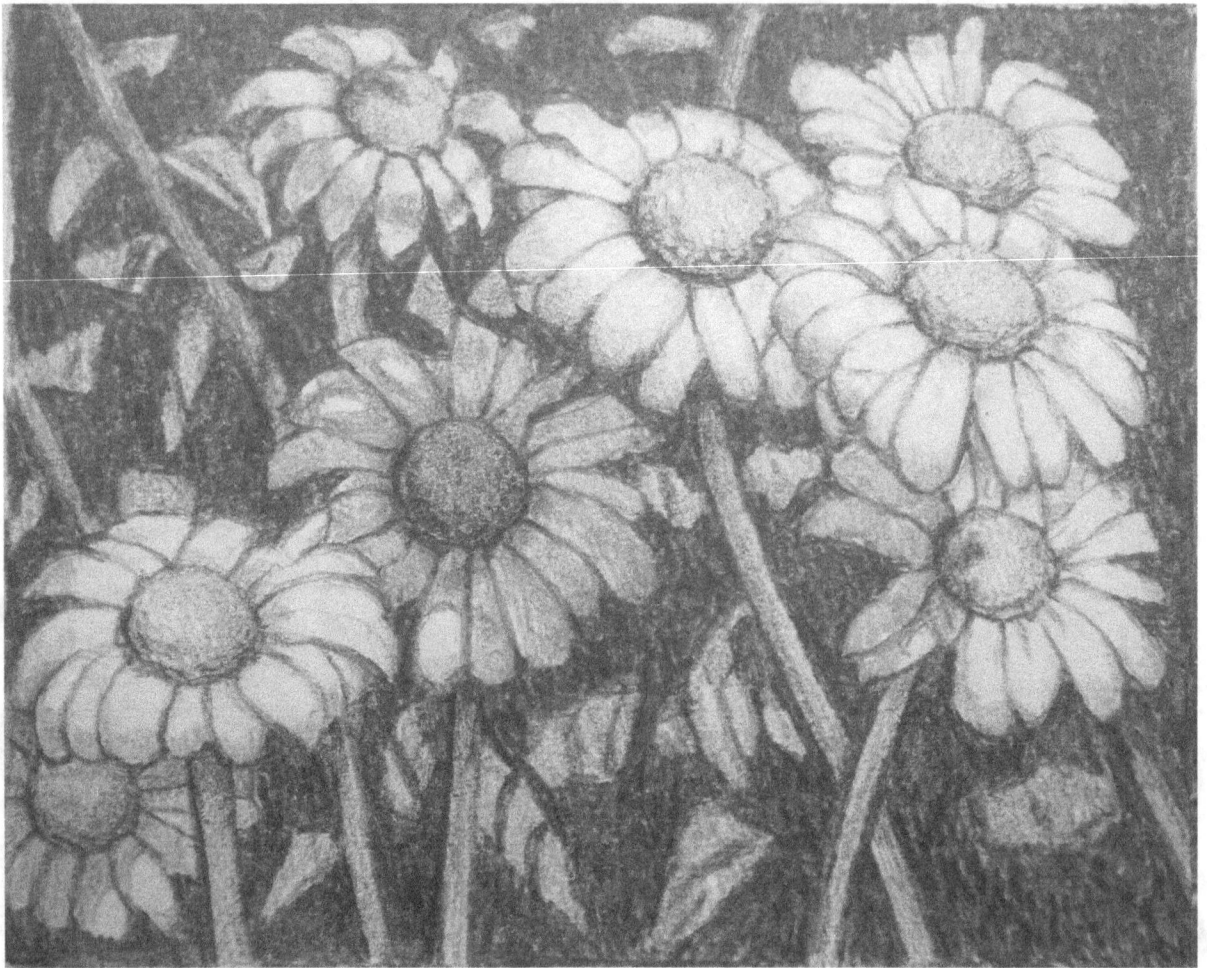

These daisy heads link into the previous exercise for the abstract shapes that can be found within. A close inspection will reveal forms that resemble nothing in particular.

Some appear to float in space; others can be affixed onto lines. Heavy blocks of tone run throughout the background which contrasts against forms that are familiar: the daisy heads.

However, it all can overwhelm without a simplified view.

This is why I used the adjustable frame made from 2 L-shaped pieces of card, as shown within drawing project 3.

This frame has been used to edit out unnecessary background clutter.

As can be seen, only eight daisy heads are visible in the composition. Some heads are in sunlight and others are in shade.

A similar treatment to the beach stones in drawing project 3 will be required here. This means expressing reflected light against a dark background. A three-dimensional effect in the flower heads will result, rather than those that appear cut out.

The previous exercise on abstract shapes will help make this project more feel achievable.

1: Onto the sketch paper, I drew a rectangle measuring 11x14cm. To make the drawing easier, I drew the daisies as simplified shapes in which the intricate forms can inhabit. To this end, I drew out eight disks to represent the stamens and surrounded each with an outer disk. These will represent the petals. I observed the orientation of each to suggest various angles.

2: Within the outer disks, I drew out the petals. Notice how each petal differs to the others. Expressing these organic variations will guard against the 'star' shape of the idealized flower.

3: I began shading the stamens. Despite being yellow, they are fairly dark in tone, so I reflected this tonality with quite heavy shading. Notice the edges are heavier than the middle sections.

4: Although the daisy petals are white, don't let this conception interfere with the tonal values on the petals, for some are much darker than others. In fact, white objects can appear very dark under certain conditions.

I shaded in areas of petals that fall in shadow, omitting areas of sunlight.

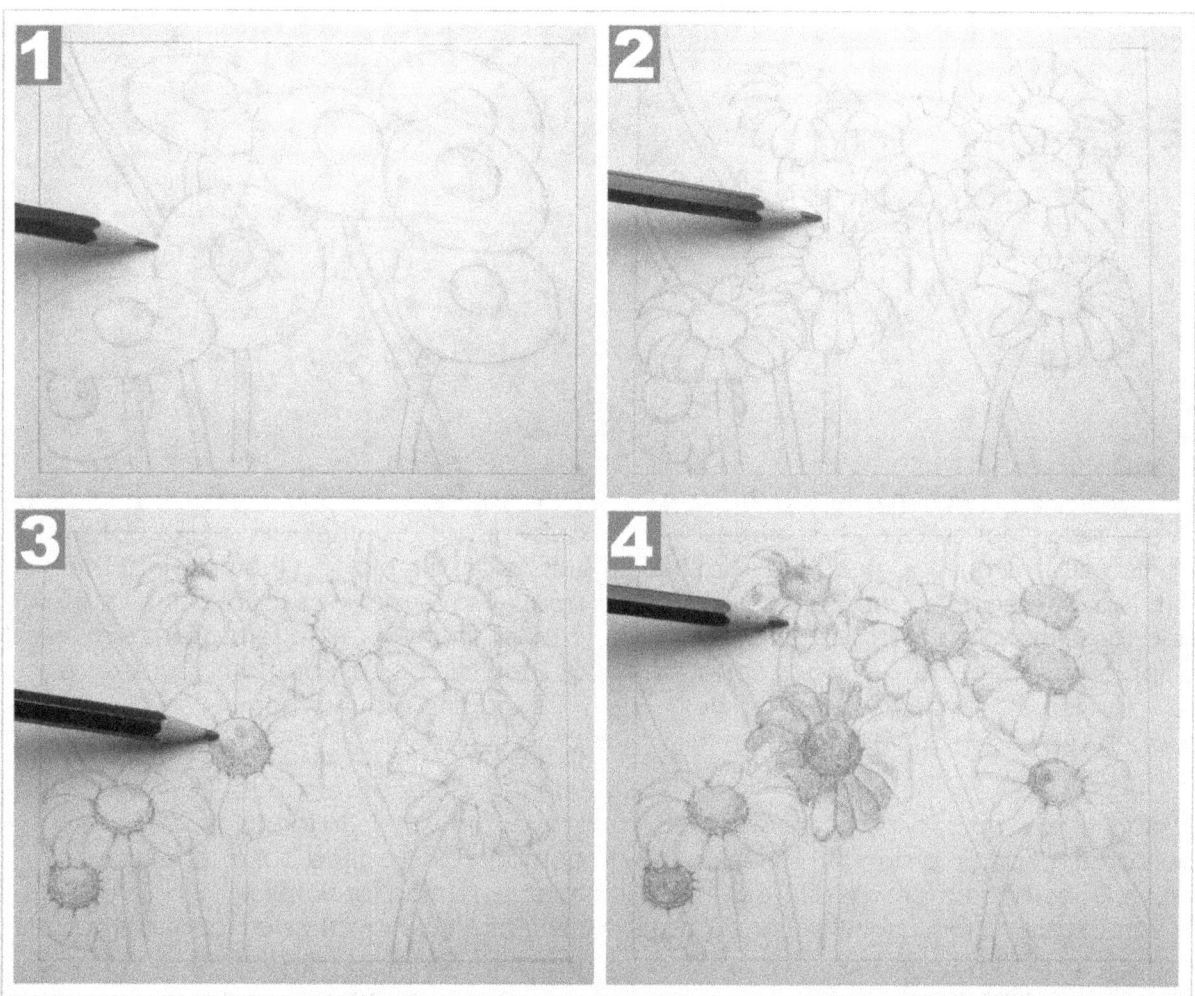

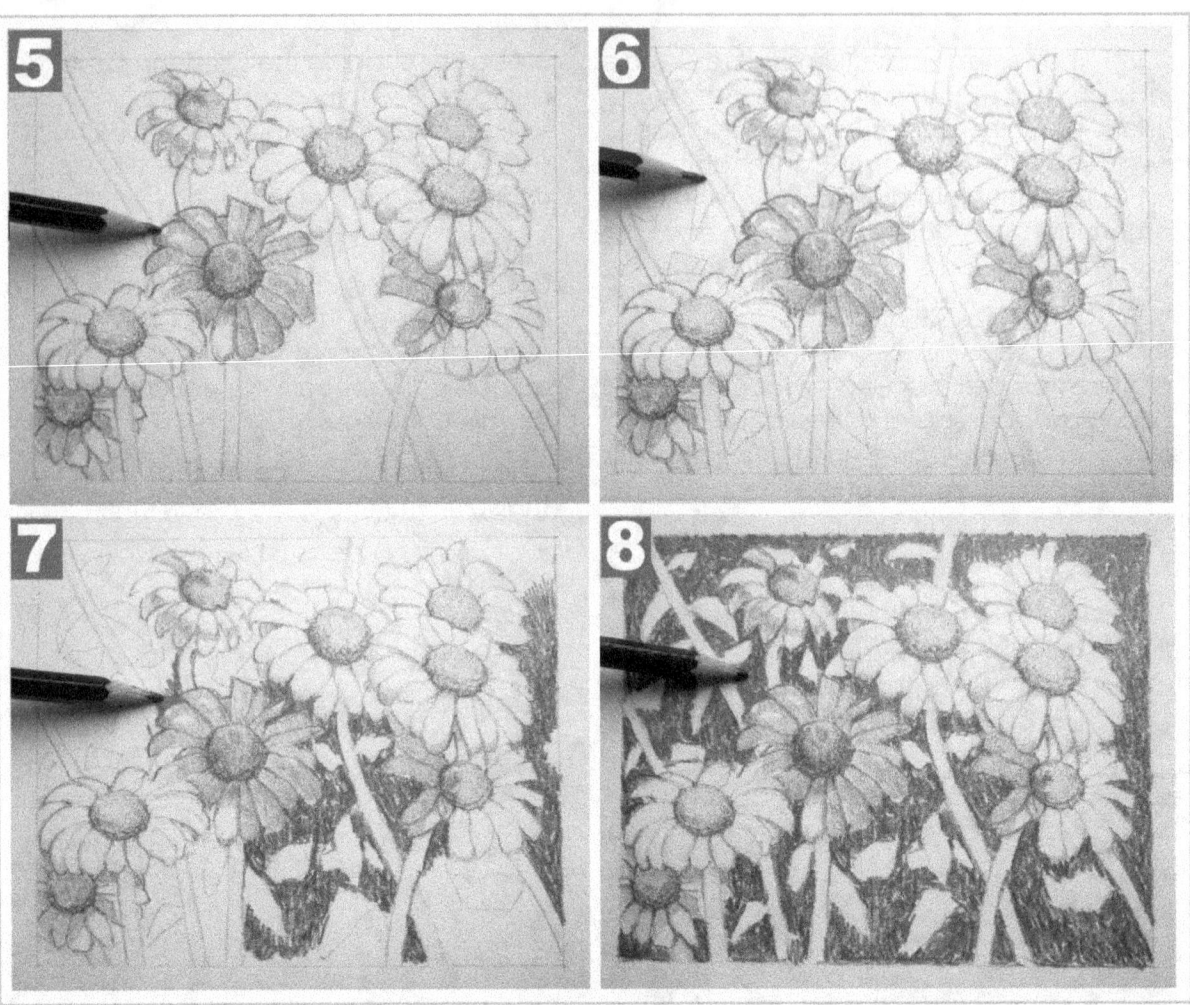

5: I continued to work moderate shading over other select areas of the daisies, particularly the one located third from the left. The difference in tone between this one and those in sunlight will bring about a dappled effect on flower heads. Tonal shifts towards the edges of the petals will help suggest how each curve away from the viewer.

6: Notice how each daisy head relates to one another and the stems from which they grow. From the stems, I was also able to plot the background foliage. I was careful not to express too many leaves, or they could clutter the composition.

7: As can be seen here, each stem links the daisy heads together, almost like dot-to-dot. This helps with plotting the drawing. The stems also form a vital focal point, for they are not simply wire-like formations expressed as lines, but possess breadth. I took care with shading around them.

8: The daisy heads and stems create interesting negative spaces from where the leaves are visible. In formulating the composition, I edited out most of the foliage, aiming for simplicity. Blocks of dark tone can now create stark contrast against the bright daisy heads. I applied heavy shading to the background.

9: I continued to work heavy shading between the daisy heads and stems, aiming for an expressive feel. Having a good scribble is always satisfying. In contrast, soft shading was applied to select areas of the stems. Notice how they vary in tone. This may seem incidental, so don't be tempted to shade all the stems as one value.

10: The tonal variations in the stems should now key into the tonal variations on the daisy heads, making both appear to 'belong' to the same setting. I darkened the outlines of the petals that fall in shadow, creating disparity to those that fall in sunlight. Varying the heaviness of lines is key to a sensitively portrayed drawing.

11: I introduced dark outlines to the outer reaches of the daisies to illustrate the curvature of petals into shadow. I then expressed shadow bands on the flower heads, where light and reflected light meet. The beach stones of drawing project 3 can be referred to here.

12: Finally, I applied delicate yet crisp outlines to the sunlit shapes on the daisy heads. Often the shape of shadow will take precedence over the shape of light, yet both have shapes. A dappled feel is reinforced.

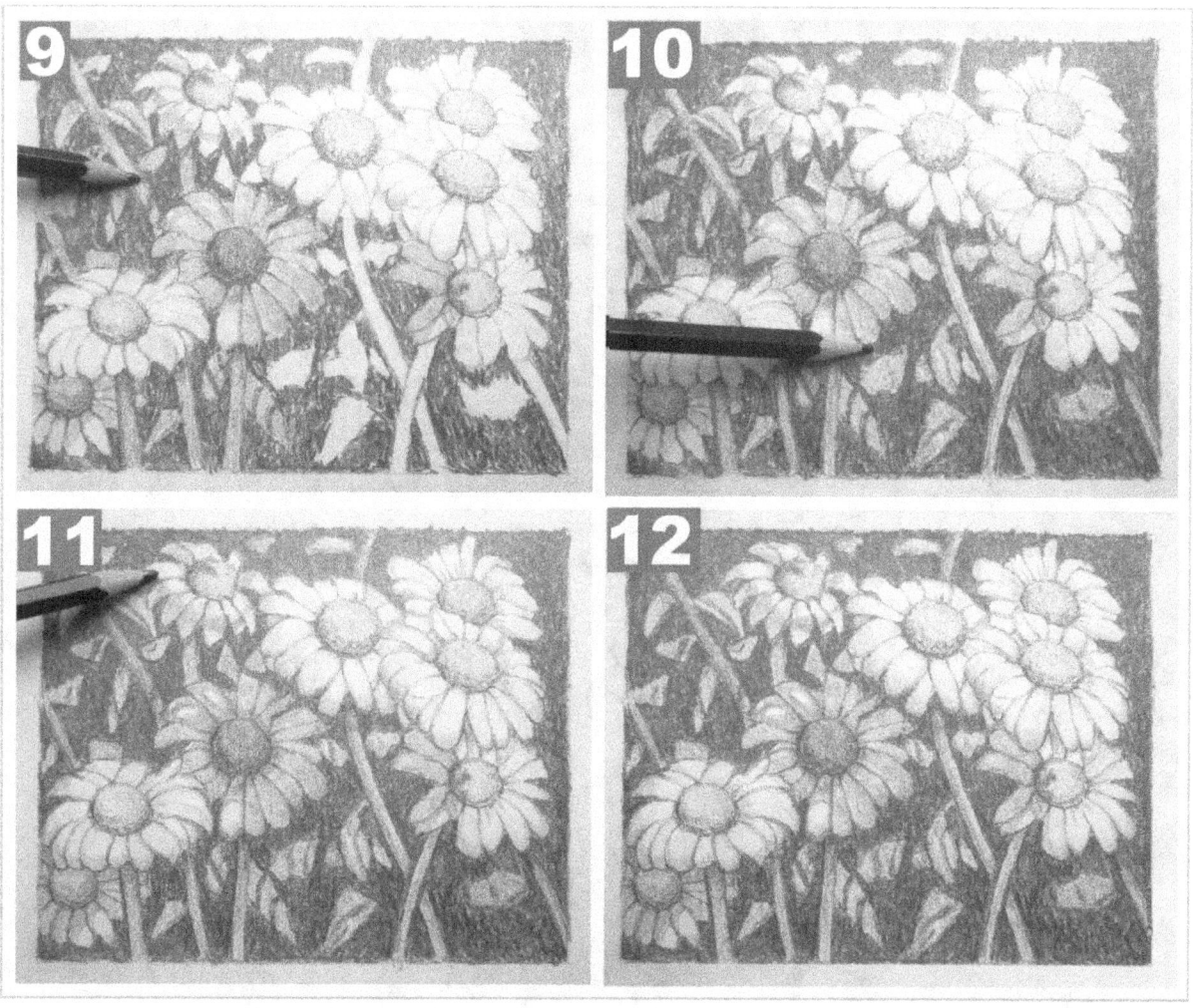

Drawing Project 8: Auguste Rodin's Sculpture *The Kiss*

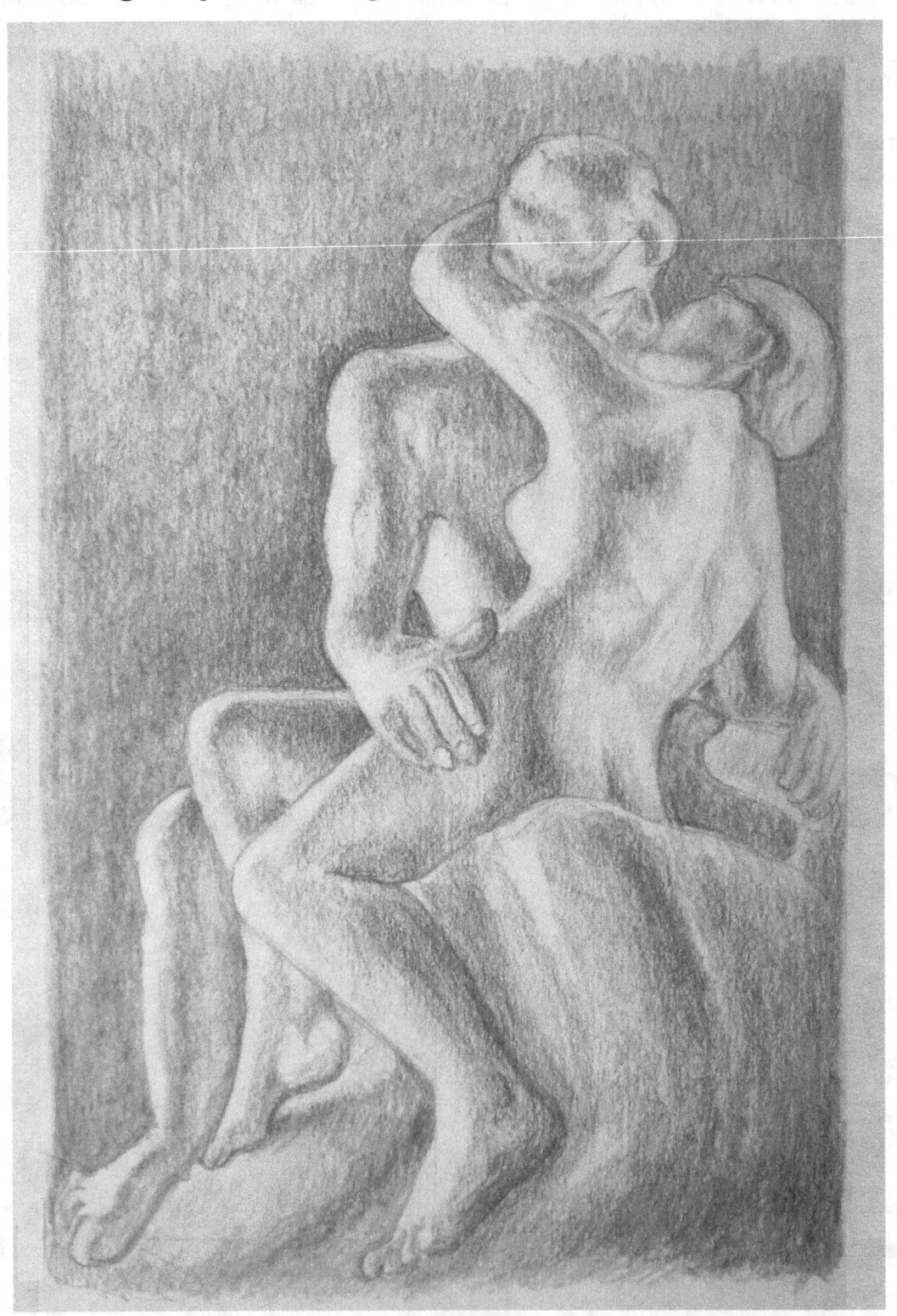

August Rodin's *The Kiss* (1882) is a sensual sculpture featuring a couple in embrace.

Exercise 8 on drawing abstract shapes has been formulated for subject matter like this; fluid lines and odd shadow shapes commandeer.

In accordance with the aim of this book, freehand drawing is encouraged. To make the project manageable, I have divided the drawing into four to show the composition stripped to its basic elements. The frame used here measures 13x19cm.

1: Only the legs of the couple can be seen here. Without prior knowledge of what the subject matter depicts, the lines would appear meaningless. This is the view to retain. Notice the twisted triangles and quadrangles within this lower left quadrant where some lines run at 45 degree angles.

2: This quadrant is sparser than the first where only two chief vertical lines occupy the space. Notice nooks and crannies along the lines that suggest muscles and tendons. The remaining area is blank.

3: With the first two squares complete, the third will seem a little easier. Really, drawing is about piecing the jigsaw together to form a scene. Notice diagonal lines running across the quadrant and how they join up with the other two to suggest the couple's torsos.

4: This final quadrant chiefly comprises two lines running diagonally. This will represent the female's back leg and rump. Such angles feature heavily within *the Kiss*, which gives the composition dynamism.

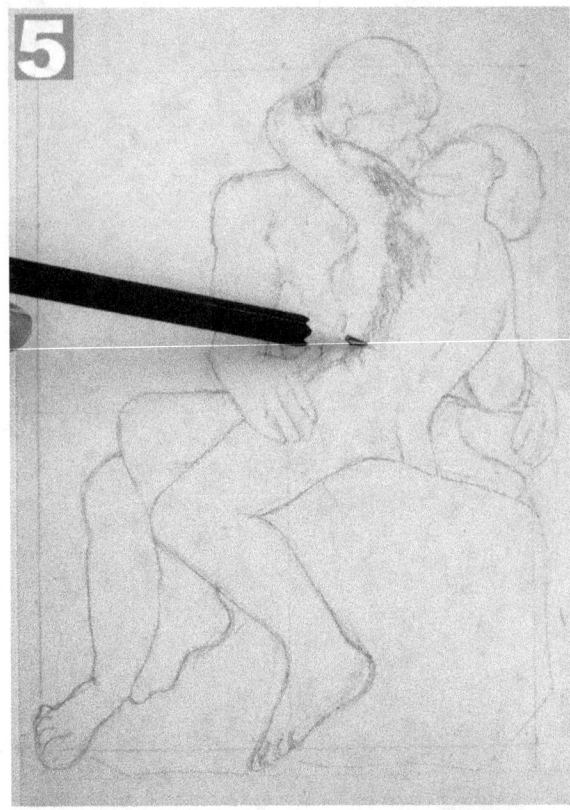
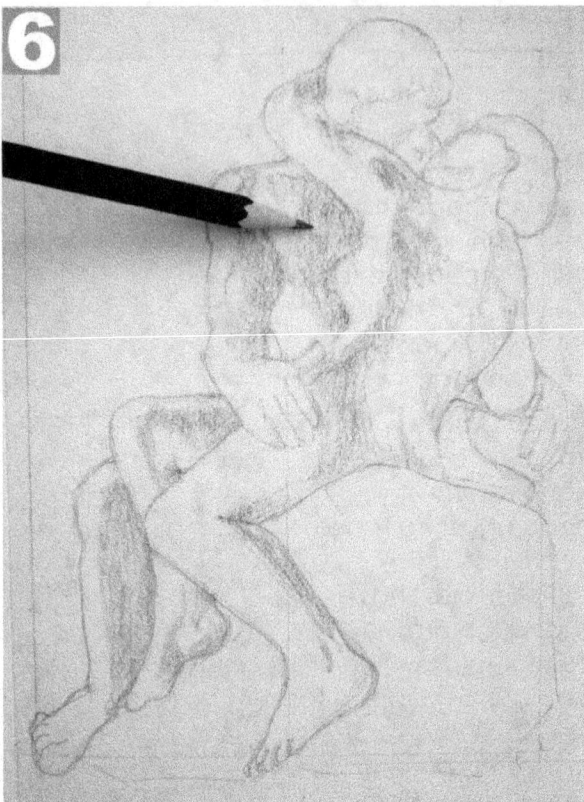
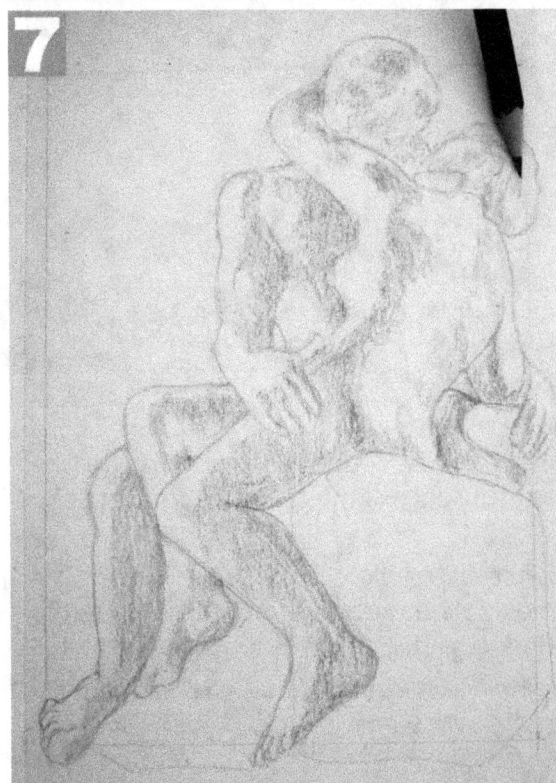

5: With the outlines complete, the shading can progress. A ribbon of shadow appears to meander down the female form like paint. In places the ribbon widens out; in others it becomes narrow. This ribbon is where light and reflected light meet and will help make the figures appear three-dimensional.

6: Here, the ribbon was elaborated upon as I worked over the legs. I applied softer shading on either side to suggest rounded contours. The male form possesses expanses of shadow that are rather flat by comparison. The limbs were expressed via similar tonal values.

7: The heads feature patchy shadow where bands of light run through. I reinforced outlines to add weight where the figures meet. I then shaded in the thighs and calves of the female figure, leaving highlights untouched. Notice dark patches on the buttock, elbows and forearm.

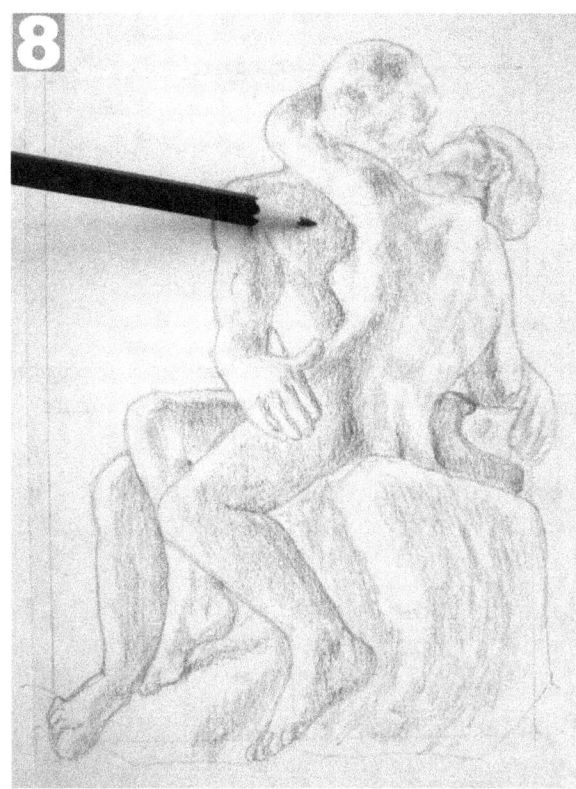

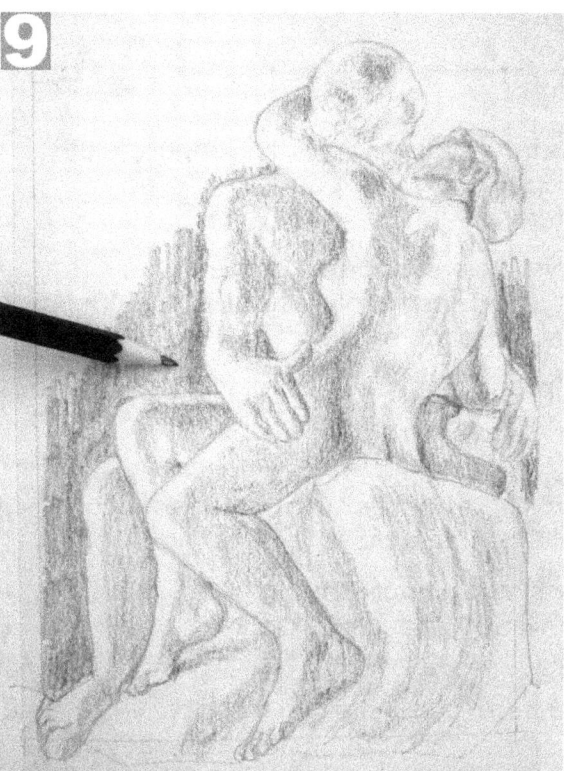

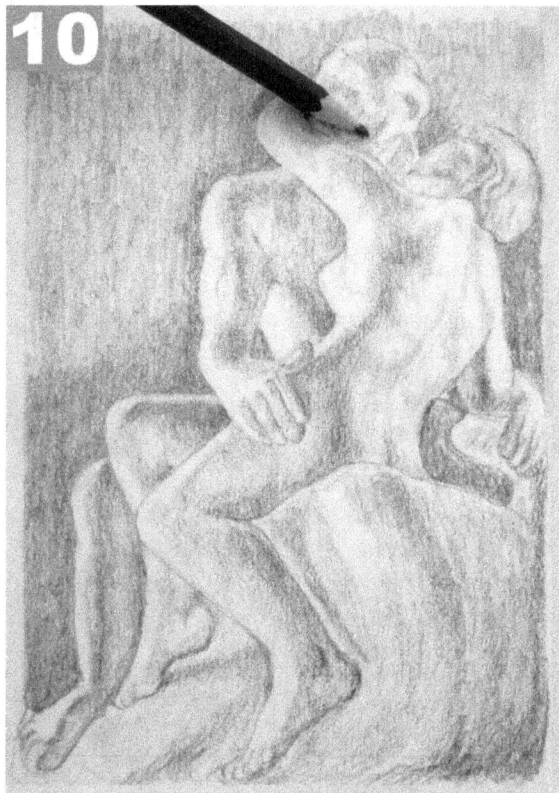

8: I darkened sections further by working over areas again as shown in the initial exercises within this book. The result is another, darker ribbon superimposed over the first. Dark patches meet up and broaden out in odd knotted shapes. This can be seen from the woman's left arm, right down to the back of her left heel. Faint serrations were expressed on each side of the female's spine.

9: Streaky pencil marks were applied to the block of marble upon which the figures rest. The background was then briskly shaded in vertical strokes. Care was taken not to go over the highlights of the figures. Notice how the highlights show up against the darkened background.

10: The lower background was darkened to suggest a light source. Select areas of the ribbon were then elaborated upon and refined in order to further describe how the light hits the figures. Often, the final touches can make all the difference.

GLOSSARY

Abstract shapes: The visual language of shape or form independent of visual references to the world.

Cold pressed paper: A process where the paper is pressed minus heat. The texture of the paper is preserved.

Ellipse: A symmetrical oval shape, often an oblique view of a vessel's top.

Fields of vision: In the context of these drawing exercises, what can be seen within each quadrant of a composition.

Five Principles of Drawing: These are: 1 Outlines; 2 Spaces; 3 Relationships; 4 Tonality: and 5 The whole.

Frame: In the context of these drawing exercises, the frame forms the edges of the composition to be drawn. 'L' shaped card can be used to determine the edges of an image.

Gradation (pertaining to tonality) A gradual shift from one tone to another.

HB pencil and 2B pencils: The so-called lead of the pencil comprises graphite and varying amounts of clay. The 'H' stands for hard and 'B' for black. The softer the pencil, the higher the concentration of graphite. The HB pencil falls in the midrange. The 2B pencil is a little softer than the HB, giving darker shades.

Hot pressed paper: A process where heat has been used in the pressing process, creating a smooth surface. This is ideal for applying detail. Medium grain paper has been used for this book.

Incremental tones: Expressing tones by degrees.

Left brain: Where language and logic resides. When it comes to drawing, the left brain can interfere with interpreting honestly what is seen in front. This is due to assigning rules and labels to the subject matter during the drawing process.

Linking lines: In the context of these drawing exercises, lines that connect two or more features within a composition.

Negative space: The background area that can be seen between the subject matter of a composition.

Positive shape: This describes the subject matter as opposed to the background shape (or negative space).

Right brain: Where creativity resides. When it comes to drawing, the right brain predominates. This means seeing objects as a series of lines and shapes rather than what the object is.

Symmetry: A shape or form that corresponds on opposite sides.

Tonality: The value of how dark or pale an object is.

Vanishing point: The point where parallel lines of an object such as a road or railway track appear to meet on the horizon.

Visual awareness: The ability to visually gauge the characteristics of objects seen in front.

Weight of marks: How dark or pale a line or mark appears. Dark marks appear 'heavy'.

Weight of paper: This is measured by grams per square metre (or GSM). 150 GSM paper has been used in this book. Paper lighter than this will be too thin.

Other Books by the Author

No Need for an Easel or Mahl Stick: Oil Painting for the Absolute Beginner made Simple

Why do My Clouds Look Like Cotton Wool? – Plus 25 Solutions to Other Landscape Painting Peeves

Why do My Ellipses Look like Doughnuts? – Plus 25 Solutions to Other Still Life Painting Peeves

Why do my Skin Tones Look Lifeless? – Plus 25 Solutions to Other Portrait Painting Peeves

The Ultimate Oil Painting Solution for Landscape Art, Portraiture and Still Life

Portrait Painting in Oil: 10 Step by Step Guides from Old Masters

Skin Tones in Oil: 10 Step by Step Guides from Old Masters

Oil Painting the Mona Lisa in Sfumato: a Portrait Painting Challenge in 48 Steps

Oil Painting the Angel within Da Vinci's the Virgin of the Rocks

10 Bite-Sized Oil Painting Projects: (Books 1, 2 and 3)

Landscape Painting in Oils: 20 Step by Step Guides

The Artist's Garden in Oils: 18 Step by Step Guides

How Can I Inspire my Painting Class?

Draw What You See Not What You Think You See

Begin Drawing with 8 Exercises and 8 Projects: Achievable Goals to get you to Draw

Oil Paintings from Your Garden

Oil Paintings from the Landscape

Illustrated Children's Books

Katie's Magic Teapot and the Cosmic Pandas

Katie and the Cosmic Pandas' Deep Sea Voyage

Katie's Magic Teapot Omnibus Edition

Ben's Little Big Adventure

About the Author

I graduated from Kingston University, Surrey and attained a PCET teaching qualification from Warwick University. I have taught and written numerous books and articles on art.

This book has been inspired by my teaching experience and from my research into my other art assignments.

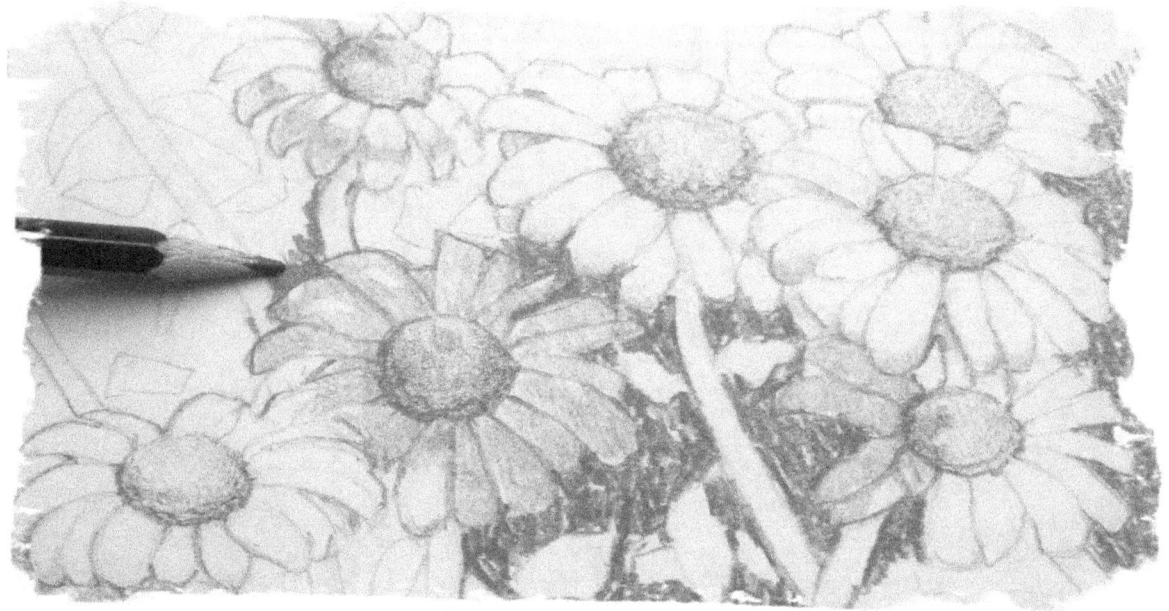

www.ingramcontent.com/pod-product-compliance
Lightning Source LLC
Chambersburg PA
CBHW081459220526
45466CB00008B/2715